the
artist's guide
to grant writing

● ● ●

How to Find Funds and Write

Foolproof Proposals for the Visual,

Literary, and Performing Artist

gigi rosenberg

Watson-Guptill Publications

New York

To my parents,

all three of them:

Lilli Ann Killen Rosenberg

Robert Shore

Marvin Rosenberg

Published in the United States by Watson-Guptill Publications, an imprint of the Crown Publishing Group, a division of Random House, Inc., New York.
www.crownpublishing.com
www.watsonguptill.com

WATSON-GUPTILL is a registered trademark and the WG and Horse designs are trademarks of Random House, Inc.

Library of Congress Cataloging-in-Publication Data

Rosenberg, Gigi.

The artist's guide to grant writing : how to find funds and write foolproof proposals for the visual, literary, and performing artist / Gigi Rosenberg.

p. cm.

Includes bibliographical references and index.

ISBN 978-0-8230-0070-8 (alk. paper)

1. Arts–United States–Finance. 2. Arts fund raising–United States. 3. Proposal writing for grants–United States. I. Title. II. Title: How to find funds and write foolproof proposals for the visual, literary, and performing artist.

NX705.5.U6R67 2010

700.79–dc22

2010034585

Printed in the United States

Design by Claire Vaccaro

10 9 8 7

First Edition

acknowledgments

This book would not have come to be without the encouragement and wisdom of Michael Broide; Sophie Broide; Ariel Gore; my editors, Carrie Cantor and Amy Vinchesi; and my agent, Rita Rosenkranz. I am also grateful for the guidance of editorial director Victoria Craven.

Many colleagues read and commented on early drafts. Much appreciation to Judith Aftergut; Pam Summa; and everyone in my Tuesday-night writing group, especially Kerry Cohen, Michael Guerra, Ken Olsen, Katie Schneider, Jeffrey Selin, and Ellen Urbani.

For crucial help along the way, I'm grateful to Christina Katz; Vicki Lind and everyone in her Job Club, especially Jill Kelly, Donna Matrazzo, and Nick Thomas; Melissa Potter; Ben Killen Rosenberg; Evan Shore; Claire Vanderzwan; and Morrie Warshawski.

Many artists and grant specialists generously gave hours of their time in interviews with me and donated their writing for examples in this book. Unfortunately, not all of their stories made the final cut. For sharing their work, many thanks to Karen Atkinson, Linda Austin, Justine Avera, Mira Bartók, Jackie Battenfield, Leo Berk, Christa Blatchford, Helen Borten, Tracy Broyles, Sage Cohen, Bonnie Collura, Helen Daltoso, Marc Dennis, Sean Elwood, Bret Fetzer, Joan Findlay, Helen Hiebert, Linda Hutchins, Kemi Ilesanmi, Gretchin Lair, Aaron Landsman, Jon Lapointe, James Lapp, John Jota Leaños, Ken May, Caroll Michels, Monica Miller, Christopher Mooney, Licia Perea, Shannon Planchon, Aviva Rahmani, Rita Robillard, Ethan Rose, Dread Scott, Mark R. Smith, Kim Stafford, Cheryl Strayed, Phil Sylvester, Mary Szybist, George Taylor, Juana Valdes, and especially Grace Weston.

Heather Darcy Bhandari, Janet Bloch, Cindy Hudson, Nancy Hytone Leb, Leanne Palmer, Jen Rountree, Judith Teitelman, Ellen Thomas, and especially Eva Schweber provided key assistance during research or at workshops.

Thanks to the staffs at Creative Capital, Foundation Center, New York Foundation for the Arts, South Carolina Arts Commission, and Urban Institute for answering many research questions. My research was also informed by Judith B. Margolin's 1983 book *The Individual's Guide to Grants*, the first to focus on the courageous individual grant seeker.

Finally, thanks to you, the writers and artists who clamored for more and motivated me to write it all down.

contents

preface

Grant writing jump-starts a
conversation between you
and your art … and
your art and the world.

landed my first grant as the result of a verbal pitch. It was a rainy day in August 1972 in South Wellfleet, Massachusetts. "I'm bored," I said to my parents. "I wanna make a film. I'll put them in it." I pointed to my younger brother and sister. "Can you give me the money to buy a couple rolls of Super 8 Kodachrome and loan me your tripod?" My parents agreed … on one condition. "Don't fight with your brother and sister," my mother said. My stepfather handed me the cash. I was fourteen years old.

Three weeks later, as *Crazy 500* flickered to life in our darkened living room, the first animated credit read, "This film made possible with a grant from the Marvin and Lilli Ann Killen Rosenberg Foundation." I didn't realize then how much I already knew about funding artistic projects. I had matched the needs of my financial backers, assembled a team I knew would impress them, explained exactly how I'd spend their money, and designed a project they found irresistible. I even remembered to thank them prominently at the premier. And I made the film without any artistic compromises except for one annoyance: My sister refused to change out of her pajamas for the shoot or even wear the same nightgown each day for the sake of continuity.

By the time I reached my twenties and started applying for grants in the real world, I'd forgotten all I knew. Instead of building on my

good instincts, I floundered. I felt like I was standing on one side of a brick wall without a clue how to catapult myself over to the pot of money I'd heard was on the other side.

The first grant I wrote was to the Boston Film and Video Foundation asking them to fund a documentary film. I'd met a seventy-three-year-old Tennessee woman on a business trip who turned out to have been my grandfather's mistress for four years in the 1930s. She credited my grandfather with helping her go from a spinner in a textile mill earning $4 per week to a Southern labor leader. By a twist of fate, I'd found her.

I didn't show my application to anyone. I treated it like a top-secret communiqué between me and the foundation. In my studio apartment, when my scientist boyfriend wasn't around, I edited my work sample—a short video consisting of interviews I'd done, historic photos I'd collected, and footage I'd shot on my visits to Tennessee. The narration was my own shaky voice.

The process of answering the questions on the grant application, assembling my work sample, and calculating a budget was agonizing and filled me with an odd shame. I was afraid to commit my plans to paper, and this fear turned into resentment at having to explain myself. I wanted to be a filmmaker, I wanted the money to make a project, but I didn't want to have to ask for it in black and white. *Why won't they just give it to me? Why do I have to justify it?*

Something deeper was going on that I couldn't see at the time. I wanted to be "chosen." I wanted this foundation to tell me I was a filmmaker so I could feel like one. I wanted permission.

Both of my parents were professional artists. My mother made one hundred-foot-long mosaic murals in our basement. At our house, if you could make it, you didn't buy it. On my grandmother's black-and-gold sewing machine, I stitched outfits for my Barbie dolls and then clothes for myself to wear to school. I developed photographs in our darkroom and built clay sculptures in my mother's pottery studio.

When I visited my father in Manhattan on Sundays, I fell asleep to the sounds of his paintbrush swishing in water, my cheek resting on

his scratchy green couch. Once, I posed for a painting of a girl burying a dead pigeon for a children's book he was illustrating.

"You're so lucky your parents are artists," people told me. And I *was* lucky: Making art wasn't precious or separate from everyday life. It was as valuable and necessary as food and water. Even if at times the whirl of commissions and productivity threatened to overwhelm me. But families are complicated, and even with that upbringing, I was still looking for somebody else to tell me I was an artist. Sometimes even with two artist parents—maybe *especially* with two artist parents—there doesn't feel like there's enough room for another artist in the family.

I didn't get that grant for the documentary film. Nor did I get several others I applied for after that.

Then something happened. I accepted a job at Larry Miller Productions, where I eventually was promoted to producer and then vice president. At work, I made slide shows, films, and videos for non-profit and corporate clients. It wasn't the artistic career I'd dreamed of, but I was making films and honing my business and marketing skills. At the same time, I signed up for every class I could find on grant writing. For a summer course at Harvard, I slogged through pages of thick foundation directories, studying the organizations that gave money to worthy causes. Our perpetually cheerful professor taught us how to discern an organization's interests and passions so we could match ours to theirs. We stared long and hard at application questions and learned that most applications ask the same questions, even though they might look different at first.

This research was tedious, but I was fascinated that something artful could find support in this bureaucratic and rule-filled world. We learned about organizations that believed in the value of art and offered grants of money, equipment, time, and even studio space to help artists create.

One night, the evening before another grant deadline, I finally realized I couldn't write my next grant without help. Since I'd written that first one, my boyfriend had become my husband. I shook him awake. "Can I read this to you?" I asked. "How does this sound?"

He listened. But then instead of answering me, he asked me some questions: Why did I want the money? What did my project entail? How was I going to accomplish it? Why did I think it was important? And on and on.

I stammered and fumbled through my answers, but the more I talked, the clearer my ideas became. His hard questions made me say out loud what I wanted—what my project was and why I wanted to do it. This time, instead of shame, I felt excitement.

I hadn't realized until then that my scientist husband had a lot of experience as a grant writer—not for art projects but to fund his physics research. His attitude as a grant writer was nothing like mine. He felt completely deserving of funds and wasn't afraid to explain in detail why he wanted the money, how he planned to spend it, and why his project was urgent. He used numbers and statistics to support his case. He didn't ask for permission; he asked for cash.

It's true that scientists have it easier than artists. There's more funding available for science, and most scientists haven't been told that their work is unimportant or self-indulgent. I wondered, What if I wrote my applications with a scientist's conviction? My husband didn't doubt his physics. What if I didn't doubt my art? With that revelation, I began to write with more confidence, and that confidence encouraged passion. How is my art needed? Why is my project urgent?

I schemed as to how I could use numbers to build my case. For example, exactly how many people are on my mailing list? How many postcards am I mailing? How many posters am I hanging? Those numbers could be listed in my marketing plans. How much money did I raise at my fundraising event from how many donors? These numbers showed the depth and breadth of my planning and proved there was a groundswell of community support for my work.

I also learned to apply scientific language to my proposals: to say that I'm probing, discovering, or investigating sounds a lot more important than wondering about, considering, or contemplating. Most important, I discovered that grant writing wasn't something to do in secret the night before the deadline. It took time, and it involved other people.

The first grant I won paid for me to travel to San Francisco for a week to study performance art with Action Theater creator Ruth Zaporah. Small though it was, the grant felt like a launching pad for new artistic exploration. And it boosted my self-confidence as an artist. This time I wasn't asking the funder to tell me I was an artist; I already knew that.

Many years had passed since that first grant I wrote for the film. I'd moved to Paris for a year to study writing and acting. I'd written and performed dramatic monologues. I was drawing and painting. I was writing steadily and getting published. I was finding my own voice, my own rhythm, and my own life separate from my artist parents.

Now I knew I'd be an artist no matter what. Making art was like breathing to me. But I had to discover that through my own life experience and by continuing a steady writing practice. Now, I was asking the granting organization if it wanted to come along for the ride I was already taking—with or without them. I didn't realize it then, but this attitude that developed as I grew as both a person and as an artist made all the difference.

Then something even bigger happened. As my career and grant-writing abilities evolved, I was invited to sit on a panel—made up of working artists—to review proposals from individual artists seeking funding for projects. Our efforts as panel members were unpaid. We picked up heavy three-ring binders stuffed with applications and were given several weeks to read each submission in detail, review work samples, and score applications based on the funder's criteria.

Many of these applications read like those first top-secret documents I had once submitted: The applicants were timid and unsure. The worst offenders didn't follow directions. Some writers were self-righteous. Others didn't answer the questions completely, so I couldn't decipher why they wanted the money. Others wrote tentatively, using verbs like "might" or "could," making the project seem like it *might* or *could* never happen.

In the best applications, the writing was clear and concise. The proposal exuded energy and confidence. As I read, my excitement

about the project grew—I could see it, hear it, practically smell it. I understood how the project fit the trajectory of the artist's work. It read like a story: First she started here, then her work progressed to there, and now she wanted to advance to over there. Would we help her get to where she was already going? With our help, she might arrive sooner. She explained the urgency of her request—why she needed the funds now and not next year or five years from now.

The successful applicants didn't declare goals that were unattainable; they described projects that were doable and important to the funder. (A grant that promises to cure world hunger, for example, probably won't get funded because, as noble as that goal is, we all know that one grant can't accomplish it.) They weren't desperate or needy; they wrote like they were already winners. And they proved, through the details of their plans and their track records, that they were capable of finishing the project successfully.

Sitting on that panel deciding which projects to fund transformed me as an artist seeking funding. I had cracked the code of grant writing for individual artists. Now, I understood what it took to rise to the top of the heap, and I was on fire to share what I learned. Artists could articulate their plans and convince others to fund them. I wanted to show them how.

I began teaching grant writing to help artists craft winning proposals, and this book was born out of my popular workshops. In the pages to come, I will share the skills, strategies, and secrets of successful grant writers that I learned from my own successes and failures and from interviews conducted with dozens of artists, panel members, and decision makers.

This is the book that I wish I'd had when I didn't know whether I was an artist, and even when I did know and I wanted to have both the money and the validation that winning a grant provides. I hope that it will help you realize all you already know about grant writing and help ensure that every hour you spend writing proposals boosts your career. Let grant writing push your art into the world.

If you've never applied for a grant and want to know whether you're ready, I'll help you determine whether now is the best time. Then I'll guide you through the process, step by step—from researching, strategizing, writing, and polishing your application to following up afterward.

If you've already applied for a few grants and want to increase your chances of success, you'll discover tips for finding fresh language to enhance your writing as well as editing advice and proven strategies that will make your application stand out from the crowd. This book will accompany you on your journey from the first clicks of research through follow-up activities. It will show you how to enlist both colleagues and friends to assist you with your proposal in ways that make the process more productive—and even fun.

In the chapter on making friends with funders, I'll teach you how to talk about your work with ease and clarity anytime, anyplace. In the budgeting chapter, I describe, step by step, how to make a budget that showcases your careful planning. I even include a chapter on overcoming the psychological roadblocks you may encounter on the grant-writing journey.

If you're an artist who thrives on deadlines, grant writing is a free kick in the pants. Addressing the application questions will get you to do your homework, outline a budget, interview potential collaborators, and plan the marketing campaign—all the things you need to do anyway. And, as if that weren't enough, it will force you to complete your detailed plan by a specified date (the deadline for the grant application).

Twenty years after I dropped my first grant application into the mail slot at the Boston Film and Video Foundation near Kenmore Square, I rediscovered the work sample tape I'd made long ago in my Cambridge apartment. My curiosity pushed the videocassette into my VCR. I expected to cringe with embarrassment at how bad it was. And I was shocked—not by how awful it was but by how good it was. The footage was well shot, the subject was interesting, and the still photos I'd captured using a homemade rig on my kitchen floor were moving. Even my nervous narration was fine.

At first, I felt the excitement you feel when you unearth your first poem or drawing and see the raw promise of your younger self. And then I felt sad—sad that I'd let the Boston Film and Video Foundation decide whether I was a filmmaker. When I didn't get the grant, I abandoned the project. I gave them the power make a decision that nobody should ever be able to make about you or your work.

Now I know that it's not a funder's job to cheer me on. I ask others in my life to shout from the sidelines. Some of my friends and colleagues love that job. It's comforted me to hear that all the talented, successful, prolific, money-making artists I interviewed for this book (who include sculptors, poets, playwrights, animators, musicians, performers, writers, and visual artists) have stacks of rejection letters. "Rejections are a part of life and most certainly part of being an artist," one successful painter told me. "When your work is out there, it's bound to get rejected. When you're successful, it's a wonderful, albeit challenging, life, but you only get there by taking risks."

If one funder doesn't want to invest in your project, find another who does. And if nobody does, then begin it any way you can. Once you've started, that momentum will help your project find its audience and its financial support.

The artists I interviewed are like you and me, with the same fears, dreams, disappointments, and ambitions. They rise to the top in the grant-application process some of the time because they know and follow eight key points about grants:

1. Apply for grants. You can't win if you don't apply.

2. Don't be bitter or demanding in the application. Even if you're feeling that way, edit it out in the revising process.

3. Use the grant-writing process to clarify where you want to go, so that even if one grant application doesn't succeed, you gain something very valuable—your action plan.

4. Ask for help. Don't write your applications and assemble work samples in isolation.

5. Follow directions even when the rules seem like Kafka dreamed them up.

6. Research the funder so you match what you want with the needs and interests of the people who sign the checks.

7. Ask questions. If anything is unclear, call the funder well ahead of the deadline or ask another artist who has won the grant before.

8. Write and rewrite, have conversations, let the application sit, edit, and edit again until you wring out the words that describe the who, what, when, where, why, and how of your project. Don't give up until it's clear and concise without jargon, lingo, or attitude.

The process of writing a grant clarifies your artistic vision and propels your art further into the world. Discover how that process can ignite your brilliant career.

introduction: find the money

Grants can make the
difference between a small art
life and a big art career.

Author and visual artist Mira Bartók has won more than
$80,000 in grants to support her work over the course
of her career. The funds have paid for her to travel to
research a reindeer herding community in Norway, attend
the Bread Loaf Writers' Conference, professionally document her
paintings, and work in her studio. She has lived in Italy twice on
language-study grants and participated in residencies in France and
Israel. When she had a serious auto accident, grants even provided
emergency funds.

Without grants, Bartók still would be an artist. However, grants
helped her survive hard times, bought her time to paint and write, and
helped her market her work and earn prestige. Artists can't live solely
on grant money, but grants can speed and support the trajectory of
a career.

Something mysterious happens when you get a call that begins, "Are you sitting down?" The news that lightning has struck, that you have been chosen to receive a creative fellowship for a year of focused work in art, leaves a scorch mark on the heart and quickens the pulse to danger level. Many tributaries from your life now come rushing into one.

· KIM STAFFORD, POET ·

What *Is* a Grant?

A grant is money that an organization gives away to fund a project its founders believe in. Grants are not loans, so they never have to be paid back. But landing a grant requires work, and that work usually involves writing a proposal or grant application. In your proposal, you have to explain why you want the money, why the granting organization should support your project, and how you intend to spend the funds. You are expected to include a detailed budget and samples of your work. Your application is judged by a panel of your peers—that means other artists—in a competitive process.

Writing a proposal may sound like drudgery. You have to follow tedious instructions and dig deep into your plans. But all the hard work—the researching, brainstorming, and crafting your proposal—will not only earn you a shot at a grant but also give you the focus you need to bring your project to life and, in the process, ignite your career.

Grant writing forces you to sit down and write about your project: What is it? Why do you want to do it? Where will you do it? How

will you create it? Who'll be involved? And how will you tell the world about it? Every artistic endeavor benefits from this kind of vision and meticulous planning. Applying for a grant forces you to imagine, plan, and call on other people. And this process moves your art further into the world—no matter the result of your efforts.

What Do Grants Pay For?

A grant can fund career advancement or the creation of a new project. It may take the form of a cash award, equipment access, or a residency that provides time and space to work.

- *Professional development grants* can pay for you to take a class, attend a workshop, hire a consultant, build your website, produce marketing materials—anything that advances your career as a professional artist.
- *Project grants* fund the creation of a new work or a portion of that work. A project might be a theater event, a dance performance, an art installation, a series of paintings, or a book. Some grants may specifically provide studio space, equipment access, or emergency funds for artists in dire financial straits.
- *Awards* and *fellowships* are the best kinds of grants because they're usually "unrestricted"—no strings attached. An artist can spend the money to support future work in any way she wants.
- *Residencies* technically are not grants; they provide space and time for an artist to work, usually in a community with other artists. I've included them in this list for two reasons: A residency application is similar to a grant application, and a residency can be as useful as a grant. Some residencies also include stipends. (See Appendix A: Where to Find Grants and Residencies on page 189 to find residencies all over the world offered by foundations and other creative communities.)

Residencies are as diverse as the organizations that offer them. You could be the only artist or one of fifty. You might teach a workshop at a local school or give a reading. Some offer rural solitude for uninterrupted creative work and others offer the bustle of an artistic community. When I did a residency at Caldera in Oregon's Cascade Mountains, I had my own A-frame house with a kitchen, sleeping loft, and workspace. For a week, my only interruption was the sound of salmon jumping in the river that gurgled by my back deck. With long stretches of time broken up by hikes around Blue Lake, I could edit, write, paint, and dig deep into my next project.

Where Do Grants Come From?

One of the best resources for artists seeking grants from anywhere in the country is the New York Foundation for the Arts (NYFA), whose mission is "to empower artists at critical stages in their creative lives." Established in 1971 by the New York State Council on the Arts to develop individual artists throughout the state, NYFA is funded by public agencies, foundations, corporations, and individual donors.

Perhaps the most useful service that NYFA offers is a free database called the Source (www.nyfasource.org), which is updated daily. In 2010, the Source listed 2,900 award programs for individual artists, including cash awards, emergency grants, scholarships, residencies, space awards for living or work, equipment access awards, honorary prizes, and grants for professional development.

● ○ ○

The New York Foundation for the Arts (NYFA) is one of the best resources for artists seeking grants from anywhere in the country.

Grant Opportunities by the Numbers

○ ◉ ●

In 2007, literary artists were eligible for more awards than any other single artistic discipline, with 1,169 of 2,628 total awards (44%) slated for literature. The visual artists were a close second with 1020 (39%).

Musicians and composers were eligible for 987 awards (38%), media artists for 805 (31%), theatre artists/playwrights for 781 (30%), dance artists and choreographers for 628 (24%), performance artists/interdisciplinary artists for 486 (18%), and design artists for 426 (16%) of all awards. Folk and traditional artists had access to the fewest number of awards that year, with 401 (15%).

By far, most of the awards listed in 2007 were for cash grants, with 1,748 of 2,602 total awards (67%). Residencies were the second-largest category, with 465 (18%).

Source: These data were compiled by the Urban Institute for a study it conducted for the New York Foundation for the Arts (NYFA) comparing awards for artists between 2004 and 2007. The percentages add up to more than 100% because many awards are open to more than one artistic discipline.

The Foundation Center is another excellent resource for the grant seeker. Founded in 1956 and funded by more than five hundred foundations, the Center is the nation's leading authority on organized philanthropy in all areas, including the arts. It has library/learning centers in New York; San Francisco; Cleveland, Ohio; Atlanta, Ga.; and Washington, D.C.; as well as information offered at 425

public libraries and other resource centers in every state and some international locations. It also has an extremely useful database you can access for a fee (discussed in chapter 1).

The Foundation Center's website lists 20,650 grant makers that fund arts and culture. Now, here's the bad news: Most of this money is slated for *organizations*, not individual artists.

The good news, however, is the NYFA website lists almost three thousand opportunities for individual artists, and you'll discover other opportunities as you research. The additional good news is that artists can apply for grants slated for organizations if they work with a fiscal sponsor. (In chapter 11, you'll learn what a fiscal sponsor is, how to find one, and how it can benefit you.)

Who Funds Grants?

So where do these three thousand grants for individuals come from? Funding for artists comes from both public and private sources.

Government

Public grants—from federal, state, or local government—are funded by taxes. One example of a federal grant is the National Endowment for the Arts' $25,000 artist fellowship. The National Endowment for the Humanities, the Corporation for Public Broadcasting, and other government agencies also provide grants to artists. A local grant might be a few hundred to a few thousand dollars awarded by your state arts agency or town art council.

Most states offer grants to artists. In fact, 12% of total state arts funding is targeted to individual artists. As a group, state arts agencies fund 18,000 organizations, schools, and artists in more than 5,100 communities across the nation. Minnesota and Hawaii spend the most per capita on arts funding, whereas California and Florida spend the least, according to the National Assembly of State Arts Agencies (www.nasaa-arts.org).

Only 11% of individual artist grants come from the government, according to data compiled in 2007 by the Urban Institute for the New York Foundation for the Arts. The majority of grants for individual artists come from foundations and other nonprofits.

Foundations and Other Nonprofits

Private grants are funded by foundations, corporations, nonprofit organizations (like an art center or an art service organization), or individuals. Foundations are nonprofit organizations with a mission and money to support that mission. They are eligible to receive tax breaks and are required by law to donate 5% of their assets annually to programs including grants.

Foundations come in all shapes and sizes and go by different names. Some are named after one wealthy individual; others are called family foundations. You'll also hear about community foundations. Corporations may have a granting program through their corporate foundations. To make matters more confusing, some foundations aren't even called foundations—they're called trusts.

Don't let this confound you. The important point to remember about foundations and other nonprofit organizations that fund grants is that each one is as unique as the people who started it. You'll have to research each one to ascertain its particular interests and application process. The smallest foundations may have no full-time staff or website, so researching them will be more challenging. The biggest foundations have dozens of staff members and extensive websites that provide guidelines and detailed information on how to apply for funding.

Non-Grant Sources of Funding

To finance your artistic projects, you'll need to venture beyond grants for other donations that provide cash and resources. These contributions are crucial and may not only make your project possible but may also make your grant applications more attractive to funders. Funders

don't like to be the only entity funding you; they like to see that you have other means of support. Although this support can come from other grants, it also can come from cash donations from individuals or "in-kind donations" from individuals, corporations, and small businesses.

Funders don't like to be the only entity funding you; they like to see that you have other means of support.

In-Kind Donations

An in-kind donation is a contribution other than money, such as an item or service that you otherwise would have to pay for. When a printer agreed to print my theater programs in exchange for an ad in the program, his gift was an in-kind donation. Other examples of in-kind donations include the two hours that a graphic designer donated to design my marketing materials and the platter of appetizers that a local deli donated for opening night.

An in-kind donation can come from an individual, a small business, or a corporation. Caroll Michels, career coach, artist-advocate, and author of *How to Survive and Prosper As an Artist*, has orchestrated several donations from big companies. One contribution was aluminum from a major aluminum company for a sculpture exhibit. She researched companies using *Standard and Poor's Rating Guide*, wrote letters to all the major aluminum companies, and had her donor within six weeks. Another major contribution was bread and cake from Pepperidge Farm, which she and two colleagues used to sculpt a twenty-four-foot-long edible model of Central Park that featured Pepperidge Farm Goldfish crackers swimming in the park's pond.

Individuals

Individuals donate more money to good causes than corporations and foundations put together. In 2008, $307 billion in private money went to nonprofits, yet only 18% of this amount was from foundations and corporations—individuals made up the rest, according to Giving USA. In chapter 11, I present all the ways to raise money from individuals including direct mail campaigns, fundraising house parties, and creative strategies that artists from Los Angeles to New York have used to find support from individual donors.

By Nomination Only

○ ● ●

You may have heard of the $500,000 "genius award" from the John D. and Catherine T. MacArthur Foundation. This is an example of a grant you can't actually apply for; you must be nominated. Many smaller grants fall into this "nomination only" category, which can be frustrating. How can you get a grant if you can't even apply for it?

Take heart: the more you get your work out into the world—in front of curators, critics, and arts administrators—the better your chances of receiving a nomination. Often the people who review grant applications are the same people making nominations, so the more you apply for the grants you're eligible for, the greater your chances of receiving a nomination.

Grants Are Not Charity

Many artists I've spoken with over the years have told me they some-times feel that applying for a grant is like begging for charity. A grant is *not* charity. Granting organizations believe in art and its power to transform individual lives and, in turn, the world. Funding art is a crucial part of their mission, not because they feel sorry for artists but because they believe in what artists do.

A quick cruise through the mission statements of granting organizations at all levels shows an enthusiasm for and loyalty to artists. At the federal level, the National Endowment for the Arts is dedicated to "bringing the arts to all Americans." At the state level, the South Carolina Arts Commission "pursues its public charge to develop a thriving arts environment." Washington's Artist Trust's sole mission is to "support and encourage individual artists working in all disciplines in order to enrich community life throughout Washington State." The Jerome Foundation "seeks to support artists who exhibit significant potential yet are not recognized as established creators." The Puffin Foundation seeks to "open doors of artistic expression by provid-ing grants to artists and art organizations who are often excluded from mainstream opportunities due to their race, gender, or social philosophy."

These organizations and others like them need you to complete their work in the world. Your job as a grant-writing artist is to make the review panel's job as easy as possible: Follow the application instruc-tions to the letter, demonstrate that you understand the goals and missions of the granting organization, and convince the decision makers that your project is the perfect way to manifest their vision. When writing your proposal, remember that the organization you're applying to already believes in what you do.

1 • start your research with you

Where in the world are you going next? Start by looking at the world inside you.

When mixed-media artist Rita Robillard prepares to apply for a grant, she doesn't start by browsing the Internet or the public library; she starts in her studio. She looks at her work and asks, Where can I take this next? Where can I go from here? She pores over her notebooks and scrapbooks of ideas as she considers where she wants to expand her work. She'd probably do this even if a grant deadline weren't looming, but a deadline compels her to sit down and let her work speak to her. "To win a grant, you must have a vision of what you want," she said.

The first step in articulating that vision is career planning to ensure that you're applying for a grant that will help you get to where you want to go. Because the grant-application process is so time intensive, you need to make be sure that you're applying for a grant that's in alignment with your career plans. Your planning will help you envision where you want to go next, how to build that bridge into your future, and how grants can help you get there.

Before you start surfing the Web in search of organizations or individuals ready to write you a check, set aside time to contemplate where you want your career to go in both the short term and the long term. What are you creating right now that could benefit from writing a grant application? What aspects of

> Because the grant-application process is so time intensive, you need to be sure that you're applying for a grant that's in alignment with your career plans.

your creative projects need support? What does that support look like?

Monica Miller, former director of programs at Washington's Artist Trust, has led workshops for artists on the business of art, including grant writing. She tells artists "to think about what they're making and then to daydream and brainstorm all the things associated with making their work. Is it a residency they need? materials? subcontracting a portion of the project? Is it time or a studio rental?" She encourages them to free-associate and think as broadly and as loosely as possible.

The artists in her program also make long-range plans. Miller urges artists to envision beyond their goals for this week or this year. She urges them to imagine a scenario in five or even ten years. "What's a typical day? Who are they talking to? What comes up in that day? If they're in New York City at a gallery opening, they need to hold that big picture. Then connect the dots between now and then."

What's your big vision? Is it a New York City gallery or a studio on Vashon Island, a short ferry ride from Seattle? Between now and there, what are some of the baby steps you'll have to take?

Your career planning also may involve studying the careers of artists who are further along than you and talking to artist friends about their plans. (See Appendix C: Additional Resources to Support Your Career for books that will help you dig deeper into your career plans.) If you want to get to a Manhattan gallery opening, of course you won't know every step of the way, but by envisioning that mile marker, your path will become

clearer—whether your next step is mounting another performance piece, spending a month at a residency, or hiring a mentor to learn a specific skill.

After you've spent some time envisioning your art life down the road, make a list of all your projects, large and small. Include *every* project, from the ones in those mental folders labeled TOO WEIRD TO CONSIDER and WHEN I WIN THE LOTTERY to your dream projects. Then for each project, list all of its separate parts, the actions you'll take, and the materials needed.

If your project is a performance piece, for example, the list might include items such as time to write, studio space to rehearse, a choreographer, and fabric for costumes. To write your historical novel about nineteenth-century Russian royalty, you might need a research trip to St. Petersburg. To finish your memoir, you might need a one-month residency that pays a stipend. To bring the first draft of your play to its final form, you might need to stage a public reading with professional actors. To launch a new series of paintings, you might need to hire a studio assistant to organize your workspace.

PROJECT/PROFESSIONAL DEVELOPMENT	ACTIONS/SUPPLIES
Complete novel	Research trip to Russia Time to write at residency
Upgrade website	Website designer
Create series of paintings	Art supplies Larger studio space
_____	_____
_____	_____
_____	_____
_____	_____

Your list also may include items needed for your own professional development. For example, to launch a national career, you need a professional website; to get more radio gigs, you need to hire a voice coach; to advance to the next level in your career, you may need to attend that $1,000 writing conference to meet agents and mingle with the literati.

Chances are, many writers and artists have found grants to pay for endeavors that are similar to those on your list.

Years ago, after I made a similar list, I realized that one of my goals was to build a website. I needed the site because I wanted to be published at the national level in a book or a magazine. Without a professional-looking website, I couldn't compete. I searched for a professional development grant that would pay for marketing materials that included the creation and launch of a website. I applied for the grant, won the money, built and launched the site, and within short order was published in a national magazine and landed a book deal.

Another time, when I was doing solo performance work, I applied for a professional development grant that would pay for me to assemble a press packet so that I could book more performance gigs. That time, I didn't receive the grant and when I called to follow-up, the grants officer told me that the panel didn't feel that I was ready for marketing materials yet. She said that they thought I still needed to build a bigger body of work before focusing on marketing. The truth stung. But in the end, I realized they were right. At that stage in my career, I was better off working in the studio than marketing. If I'd received the grant, it would have been more of a hindrance than a help to my career. So, in a funny way, the rejection was the best outcome for my career.

Create Your Organizational Headquarters

Once you have a solid idea for the project you want to fund, you're ready to research grant possibilities, fill out applications, track deadlines, follow up, and so on. The better organized you are, the smoother

this process will be. I recommend that you create a filing system to organize your research on granting organizations and a calendar to track grant deadlines. You don't want the information you collect to end up in one big pile on your desk or computer desktop, leaving you feeling overwhelmed. At a minimum, you need a calendar to record deadlines and file folders to organize information about each funding source.

The reason the grant process can be confusing and sometimes daunting is because each organization that offers grants has different rules for applying. Some don't even have an application—just a list of items they want you to send; others have a ten-page instruction manual on how to apply and offer workshops on the application process.

This means you can't send the same application to every organization; each one has to be customized. The more grants you apply for, the better and faster you will get at tailoring your applications to meet the unique and sometimes idiosyncratic instructions from each funder. Once you craft a few core components—like your artist statement, project description, résumé, and bio—you'll be able to use them as a starting point for each application.

It's easy for beginning grant writers to get overwhelmed by the research and what seems like a mysterious process. When I started, I became convinced that grants were for artists smarter than I was who had discovered some secret key I would never find. The good news (which is also the bad news) is that there is no secret key. Grant writing is a skill like any other. It requires time, practice, research, and hard work. But as an artist, you already know how to work hard, and you've mastered other skills in your career that once seemed mysterious and unattainable.

● ○ ○

Grant writing is a skill like any other. It requires time, practice, research, and hard work.

Schedule a Research Day

Step one is to organize is your time. When author Cheryl Strayed started applying for grants to support her writing, she set aside one day a month as Research Day. She didn't worry about grants all month long except for that one day. Since then, she has won sixteen grants totaling more than $30,000. The funds have bought her time to write and paid for a research trip, childcare, and travel expenses to attend a writing retreat and have partially covered the expenses to build her website.

Before you embark on Research Day, you will need the following supplies:

- List of the kinds of projects and experiences you want to fund
- Calendar or personal planner
- File folders
- File folder storage box or section in your filing cabinet
- Highlighter
- Stapler

When you find information about a grant that seems like a good match for you, download both the application and the guidelines. I recommend printing all the pages and stapling them together for each granting organization. Later, as you read the guidelines, highlight the criteria and the deadline.

On your calendar, note both the deadline and two months *before* this date; that's when you'll start working on this grant. Now make a file folder for this granting institution. If it's more than two months from the deadline, file this material in the "Grants" section of your filing cabinet.

Enlist a Research Buddy

To make Research Day more fun and productive, team up with another artist looking for similar grants. You can research solo and then

convene at the end of the day to share what you have both found. With teamwork, you'll learn about more opportunities. Plus, if someone is counting on you, you're more likely to do your homework.

You may be thinking, *Why would I want to share my research with another artist? Don't I want to keep my findings to myself? After all, the fewer artists who apply, the better my chances of winning—right?* Yes, you take a chance if you team up with Suzy Brilliant, find a wonderful grant, and share the good news with her. Before you know it, she applies for it, wins the grant while your application gets rejected. If only you hadn't told her about it, you might have won. It's possible.

"I've given people tips and then they've gotten the grant and I haven't. But that's life," says actor and playwright Aaron Landsman. "There's both a perceived and a real scarcity of resources, so I understand the impulse to hoard, but I don't see it as being particularly successful. My friends who are more successful than I am tend to be more generous people who are always willing to give you a tip. I never see that keeping it private works better than generosity."

Based on my experience and interviews with dozens of artists, I've found that teamwork helps more than hinders. You'll discover more opportunities and prepare stronger applications with advice and support from a fellow artist, and the camaraderie will keep your morale up. Also, a dose of healthy competition may inspire you to work harder. In the end, you have more to gain through partnering up than you have to lose.

Start Small and Local

Many an artist dreams of that one big grant that will enable her to quit her day job and make art full-time, without interruptions. Unfortunately, those big grants are few and far between. If you're just starting to apply for grants, you'll increase your chance of success by targeting a small one close to home.

The first grant that artist Mira Bartók won was a professional development grant from the Illinois Arts Council. The grant provided $1,500 for Bartók to professionally photograph her paintings.

Although the amount was small, that documentation was crucial to her career. With good-quality slides and transparencies of her work (the standard format at that time), she went to New York City and found a gallery to represent her. She used the same set of slides two years later to secure a one-person show in Italy.

Small, local grants tend to be easier to apply for—the applications are simpler and shorter, and the competition is less intense—than national grants. Winning small grants also looks good on your résumé and future applications, because it shows that another organization already believes in you and that you've been responsible and successful with the funding.

To start your local search, locate your city, state, and regional arts associations and find out what grants they offer individual artists. For a listing of the fifty state art commissions as well as regional artist organizations, consult the state arts agency directory on the National Assembly of State Arts Agencies website (www.nasaa-arts.org). You'll find an interactive map of the United States that links to the nation's state and regional arts organizations. For example, clicking on the state of Oregon brings up contact details for the Oregon Arts Commission.

Venture Beyond Your Backyard

To begin researching nationwide grants, check out the free listing of almost three thousand opportunities for individual artists on the Source at the New York Foundation for the Arts website (www.nyfasource. org). The list can be sorted by type of award, artistic discipline, location, deadline, and other criteria. So if you're interested in awards for musicians, you can limit the search to Music entries and, within seconds, view a list of 1,034 opportunities from 755 organizations. (Note: Other disciplines include Dance, Design Arts, Folk/Traditional Arts, Literature, Media Arts, Performance Art, Theater, and Visual Art.) Further refine your search by subdiscipline, which in the Music category includes Blues, Jazz, and Opera, among others. Other limits on the search include location, deadline, and even the type of award.

For more listings, log on to the Foundation Center website (www. foundationcenter.org). You'll find many resources for the individual grant seeker, including a comprehensive database called the Online Directory of Grants to Individuals (www.foundationcenter.org/getstarted/individuals/). For a fee, you can use this database for a month or more. You can sort the list by type of art, area of interest for the funder, and other criteria. If your library has a subscription to this service, you may be able to access it there for free.

Appendix A: Where to Find Grants and Residencies lists many grant and funding opportunities for artists. Many but not necessarily all of these grants also are listed on the NYFA site or the Foundation Center database. It's always a good idea to check several sources that relate to your discipline and not rely on one single list. Grants come and go, so check lists frequently for updates, or sign up for mailing lists from organizations in your discipline.

You may find the number of granting organizations and the many types of grants available overwhelming at first, but you'll soon realize that because different grants apply to different artists at different times for different projects, you'll be eligible for and interested in only a handful at any one time. It might take only a few hours to come up with your short list.

●○○ ◯ ●○○

The more I research, the more I find clarity. What similar projects have other artists created? Where can I place myself within the artistic lineage? All of our work fits within a historical lineage.

· JOHN JOTA LEAÑOS, ANIMATOR AND SOCIAL ART PRACTITIONER ·

Find Help from the IRS

Many foundations are small and don't have elaborate websites to provide all the information you need. Fortunately, the Internal Revenue Service (IRS) offers another resource. All nonprofits (including foundations) must file a Form 990, which lists all the information you want to know—who has been funded in the past, current board members, officers, and trustees. Peruse online 990s databases at no charge through the Foundation Center (www.foundationcenter.org/findfunders/990finder) or Guidestar (www.guidestar.org).

Think Beyond the Arts

After you've investigated what's available for funding artists, consider whether your project touches on any subjects outside of the arts. If so, seek funds beyond the art world, where competition may be less intense.

Does your work deal with any scientific subjects? Artists have landed grants from the National Science Foundation (NSF) for works with a scientific theme or that made an abstract scientific concept accessible. For example, the NSF Division of Research on Learning in Formal and Informal Settings funded the stage adaptation of the film *Stand and Deliver*, which depicted minority students excelling in higher mathematics. The money enabled high school drama clubs across the country to mount the production, which was seen as a motivational tool for educators. In another example, digital media artist Andrea Polli received a grant from NSF's Antarctic Sciences Division to interpret and present weather and climate data using sound.

Play the Matchmaking Game

You'll increase your chances of landing a grant if you find the right match. First figure out whether the funder shares your values and is

interested in the type of art you create. This work lays the foundation for writing a successful grant proposal.

Carefully study the grant guidelines that describe the funder's *criteria* to determine exactly who the funder wants to fund. Is this you? Sometimes the answer is clear. (Are you a feminist poet—yes or no?); sometimes the answer is less straightforward. Maybe you don't know whether you'd be considered an "emerging" artist or a "midcareer" artist. If you're not sure about your eligibility, ask a colleague or your artist support group for help.

If you still are unsure, study the list of past award winners. This is the best way to assess whether your project would be of interest. Sometimes who the funder *says* they fund is different from who they *actually* fund.

As you research, match your needs and interests with the funder's criteria and passions. Reread the mission statement. What might make your project irresistible to the panelists who will review your application?

As you read, highlight the words and phrases the grantors use to describe their interests and mission. They choose their words carefully to reflect their values. You may want to use these words or synonyms later as you compose your

Think about whether your needs and interests match up with the funder's criteria and passions.

answers. Echoing their language shows the grantor that you understand their mission and values. This can be tricky because you don't want to parrot back their language, but you do want your answers to show you profoundly understand their mission.

Jot down any questions that come up while you investigate. Then when it's time to have a conversation with the granting organization, you'll have a list of intelligent questions ready. Don't make the mistake of asking about an issue that is clearly stated on the website or in the application guidelines.

Your goal at this point is to assess whether the grantor is worth pursuing—is it worth your time? Your project does not need to be identical to other projects that the grantor has funded in the past, but it does need to be in the *spirit* of projects they fund—is your project worth their time and money?

Use the matchmaking process to help you decide both what to apply for and what not to apply for. As you discover organizations that fund artists, be your own best investigator. Uncover what makes the organization tick. Do you think they could love your project? Or would you have to tweak your project so much that it wouldn't be your project anymore? Do you think you could love them? Gather your prospects. Write down questions. Keep looking for the perfect match.

When I research grants, I hunt for the most obvious category for a writer—literature—and then, for each entry within that category, I determine whether the funder is interested in creative nonfiction. Then, if a funder is especially interested in work with a feminist bent, I have to decide if my project makes a statement about being a woman that might be considered feminist. Perhaps the funder is also interested in work with Jewish themes. The more my interests match up with the funder, the better.

During this process, I also need to decide what kind of grant is the best match for me right now. Am I looking to take a workshop or launch a big installation project? What kinds of projects does this funder prefer? Some grants are clearly for "emerging" artists, while others are for "midcareer artists"; which category describes me? I also assess how long and arduous the application is; do I have the time and energy to devote the next month to a mammoth application, or can I ace it in a few days?

If you're still unsure what a particular funder is interested in after doing plenty of research, call the funder and ask. But make sure you prepare for this phone call; first develop your elevator speech in chapter 10 (page 138) so that you can describe your project in a couple of pithy sentences.

Let the World Be Your Library

○ ● ●

My father-in-law and I share an odd habit: We can't leave the lobby of a library or a hotel without stuffing fistfuls of brochures into our pockets. Will I ever need to know the schedule for dolphin shows at the water park or boat rides down the Willamette River?

How could this odd habit possibly help me as a grant writer? Whenever information comes my way—whether in a brochure about a theater performance or a newsletter published by a local writers' organization—I'm always on the lookout for how other artists fund their work.

When I visit the local arts agency, I pick up its annual report to learn about both grantors and grantees. I read theater program acknowledgments and artist statements at gallery shows. As I walk in the world, I pay attention to how others are succeeding.

Foster your nosy self. Eavesdrop. Stuff your pockets with information. Ask questions. Read the acknowledgments in books. Read the donor list in performance programs. I keep a paper file folder as well as a computer folder for materials I receive that make me think, *Wow, look at that!* and then I refer back to them when I need inspiration.

your assignment

Imagine a perfect day in your near or far future when you're doing exactly what you want and being exactly who you want to be. Grab a notebook and a pen or sit down at your keyboard and record your vision by answering the following questions:

- What are you making?
- Who are you with?
- Where are you?
- What would it take to travel from where you are now to that perfect day in your future?
- What's in the way?
- What support—financial, logistical, psychological—would make your vision attainable?

This is where your research starts.

gigi's cheat sheet

- Begin your research with yourself: What do you want to do now in your career?
- Set aside one day a month as Research Day.
- Team up with a fellow artist to decrease the workload and increase your possibilities.
- Start small by searching for grant opportunities in your town, county, or region.

- If your work touches on other topics, expand your search beyond arts funding.
- Play the matchmaking game, determining which funders are a perfect match for both you and your project.
- Read all you can about the funders that interest you, especially their mission statements.
- Read all guidelines. Make sure you qualify.
- Organize your research with file folders and a calendar.
- Leave yourself six to eight weeks to prepare each application.
- Remember that grantors need you as much as you need them.

2 • make grant writing work for you

Grant writing transforms
your project from a daydream
into reality.

always start my workshops by asking, "Why write a grant?"

"The money," my students respond like it's the dumbest question they've ever heard.

"Yeah, the money." I say. "But why else besides the money?"

"Isn't the only reason the money?" They want to know.

"No," I tell them. "Money should never be the only reason."

Why? Because getting a grant is a crapshoot. There are so many reasons you might *not* win funding that have nothing to do with your application. Perhaps this year nobody on the judging panel liked watercolors. Or all the applicants did an A-plus job. Or your worst enemy was on the panel. For these and a million other reasons—all beyond your control—you can ace the application and still not win the award.

If that's the case, why waste your time? Why write a grant? If money is your only reason, then you might be better off working a couple more gigs to earn the funds to take that research trip, buy those supplies, or stage your next performance art installation. In fact, if you need money fast, some of the fundraising strategies explored in chapter 11 are better than a grant.

Before you launch into a grant application, ask yourself, *Is applying for this grant the best use of my time, or would my time be better spent creating new work?* Your time is a precious commodity. How you spend it will change the course of your life. Grant applications are projects unto themselves, and they'll take time away from your other pursuits, personal and professional.

● ○ ○ ◎ ● ○ ○

I use grant writing as a concentrated experiment to figure out what are the ways in which I can frame my next project that are interesting not only to a grant panel but also to me.

· JOHN JOTA LEAÑOS, ANIMATOR/SOCIAL ART PRACTITIONER ·

We consider our application an artist service. By going through it, artists are forced to articulate their ideas and concerns, identify an audience, think about venues, and do a budget. So, every time you write a proposal, it's an exercise to help you do it better next time.

· SEAN ELWOOD, DIRECTOR OF ARTIST PROGRAMS,
CREATIVE CAPITAL ·

If you decide to apply for a grant, make sure you're benefiting from the grant-writing process. That way, you win whether you receive the money or not. And if, after you've started the application, you realize that you'd be better off working more hours at your day job or actually working on your project, allow yourself to quit. There's always next year's deadline or another grant that will be the right fit another time.

All that said, why should you apply for a grant? To help you decide whether the process is worth it, consider all of the potential benefits.

Get Out There

Your grant application will be reviewed by at least one but likely several people—usually artists. This panel of your peers immerse themselves in your work, your plans for your project, and your aspirations. After this review process, they'll know more about you as an artist than your best friend, your spouse, or even your mother. Chances are excellent that you'll run into some of these peers again when they could help publish or promote your work. So even if a particular grant doesn't get funded, you may end up with several big fans who may be helpful to your career somewhere down the road.

Cure Procrastination

A grant application deadline forces you to get your ideas down on paper and create a plan for realizing what you want. When I wrote my grant proposal to fund creating a website for my work as a writer, I had to interview web designers, research software that would allow me to update the website on my own, and plan the site launch. Working on the application helped me develop an action list and provided a deadline; both were invaluable. I was forced to make an exhaustive plan that detailed why I needed a website now, how I would use the site to promote my work, and how I would update it inexpensively. Without the deadline, my new website would have slipped to the bottom of my to-do list.

As it turned out, I received a professional development grant from the Regional Arts and Culture Council of Portland, Oregon, to pay for website creation. But even if I hadn't, writing the grant was a free workshop on planning, designing, and launching a website, which my career needed.

> ● ○ ○
>
> The grant application deadline forces you to get your ideas down on paper and create a plan for realizing what you want.

Hone the Big Idea

The grant-writing process is a way to find your own answers to the big questions about your next project. It forces you to ask questions like: *Can I do this work? How will this work add to the world of visual art (or of literature, or of performance)?* It compels you to articulate not only what kind of art you make but also why and how you make it.

Many artists—even writers—don't like to explain why they do what they do. They don't want to dissect the meaning of their art. "Artists don't like to be nailed down," said artist Rita Robillard. "With good art we crave indeterminacy, and that seems in conflict with clarity." Some artists feel that if it can be said in words then what's the point of making it? The challenge then becomes how to be clear while maintaining the poetry.

Poet Mary Szybist, who won a National Endowment for the Arts (NEA) fellowship for her second book of poetry, has a love/hate relationship with being forced to articulate what she's working toward when she writes. She wonders whether too much explaining takes away from the work. "Poems have to have space to take on lives of their own," she said. "The danger of articulating what a poem is about is that it could lead to being overdetermined and take the life out of the work." On the other hand, the process of articulation can be useful. "There can be something very generative about being forced

to articulate a theme or an idea," she said. The process of writing her grant led her to decide on the central motif that shaped and informed her second book.

Not all daydreams are meant to be realized; some ideas are better left on the cocktail napkin. The process of grant writing lets you test the worthiness of an idea before you invest time and money into it. You may find that the more you research and write about your idea, the less you want to do it. Better to learn this while it's still a pipe dream and not a full-blown project, so you can move on to the next idea and not waste time daydreaming about a project you don't want to do.

Ask for Help

Why do humans hate asking for help? Maybe the two-year-old inside us likes to say, "I did it myself!" The truth is, no successful person is an island. We need our colleagues and friends to help us realize our aspirations, and they need us to help them. Writing a grant proposal says to the world, "I want this, my idea is worth supporting, and I need help." This step can be scary and humbling, but it's good practice for all the other asking you'll need to do for the rest of your career.

I have asked printers to donate services or provide a discount in exchange for an acknowledgment in a program. I have asked friends and colleagues to donate $10 to $25 so that I could show on an application that I had raised some of my own money to pay for tuition at a workshop at the Banff Centre for the Arts. Asking made me feel uncomfortable. Some people didn't return my phone calls or respond to my notes. Then, a few people wrote me checks for $50 and a local deli gave me wine and food platters for an opening-night reception. The asking wasn't easy; sometimes it was embarrassing. But I found out who wanted to help, who wanted to join in on my project, and this was a huge boost both to me and my project.

Practice Persistence

The more grant writing you do, the better you will become at it. With each proposal you write, you learn to express yourself more clearly, to strategize, and to express your big vision to other people.

"Every grant you apply for you're shaping your ideas more and more," said Christa Blatchford, former program director at the New York Foundation for the Arts. And it shows your determination: "Some organizations want you to apply multiple times before they give you a big grant because they want to know that you're dying to do this project, not that this project is something you just dreamed up because you want the money."

Persistence of vision is a good thing, and you never know where the proposal can take you. Jon Lapointe, former executive director of Side Street Projects, told me about an artist in one of his grant-writing workshops who had composed an excellent proposal that included a project narrative, artist statement, and ten good slides of her work. She had just been accepted into a gallery but had been relegated to the back room. Then the gallerist announced an upcoming art show and asked the artists to send him press materials. "She had her stuff ready and she sent it to the gallerist and guess what? *LA Times*, front page, full color," said Lapointe. "She had her shit together, she was ready to respond to a situation." And her readiness was thanks to the one proposal, which had become a useful tool in her toolbox.

Win More Than Money

If you get the funding, then you win all of the above benefits, and one more thing that every artist I've ever met desires: validation. "Receiving a grant is a wonderful thing. Money is only part of it," said playwright George Taylor. "With fellowships, which are very competitive, winning means credibility. It's a shot in the arm. After I received the Oregon Arts Commission fellowship, I was no longer embarrassed to introduce myself

as a playwright. For a fourth-career playwright, that's very motivational. The grant made it difficult to want to write anything else but the play."

While working on the manuscript that the NEA eventually funded, Szybist wondered, *Are the poems working? Is this project worth pursuing?* "I cycled through periods of faith and doubt, both about the poems and the project as a whole," she said. Receiving the grant restored her faith in her own work. "To have the NEA select my work for this distinction is a great gift of validation," she said. "A grant is a boost of adrenaline to the writing process."

Is now the time in your career to apply for a grant? Sometimes the only way to find out is to start. You'll learn something about yourself, your career, and your project, no matter what.

your assignment

Be honest: Would applying for a grant help clarify the next step in your art life, or would it just be another way to procrastinate instead of getting back to the studio or the writing desk? If you don't know, choose a project that would benefit from some focused time. Set aside one uninterrupted hour in your studio to sketch an idea for your next project. For now, be selfish; don't concern yourself with "helping others." Pick a project you're dying to create. What would it take to support this project—a residency? a project grant? What's your vision of the final piece? Imagine walking through the installation at the unveiling, attending the concert on opening night, or reading from the finished book of stories to clarify this vision.

After one hour, ask yourself whether you feel more or less excited. If more, can you call someone right now to collaborate on one aspect of this? Can you present a portion to your artist group? Would spending many more focused hours writing a proposal for

this project help move your art further into the world? If yes, then get to work.

gigi's cheat sheet

- Let the application deadline help you overcome your own inertia.
- Remember that articulating your idea is never easy but inspires better art.
- Understand that many people will read your proposal, and you never know when you'll bump into them in the future.
- The fastest way to learn how to write a grant proposal is to write one.
- Regardless of the outcome, your application will show the funder (and yourself) how much you want your project in the world. Let your enthusiasm be contagious.

3 • build your team

Behind every great artist is a
township of help.

When photographer Grace Weston decided to apply for a no-strings-attached $3,000 grant from the Oregon Arts Commission, her first step was to convene a group of her colleagues to look at her work. She laid her photographs on a table and asked, "How would you describe my photography if you were talking to someone else about it?" They threw out words like "psychological," "dark," "edgy," and "humorous with a twist." She scribbled down every word they said. Two weeks later, she read a rough draft of her one-page essay to a writer colleague. This essay, along with her work, would be the basis for the commission's decision whether to give her the money.

"Is the part about my childhood too self-centered?" she asked.

"No," said her writer friend. "It's interesting. Anyone can relate to the isolation of childhood and the feeling of trying to make sense of a grown-up world. And it shows your development as an artist, which is part of the question they asked."

Before she submitted her final application, she asked another writer friend to read her essay. "What's missing? What's working?" she asked. The friend read it over, suggested edits, and made sure she was answering all the questions on the application.

Weston mailed the application the day before the postmark deadline. Two months later, she received a check in the mail for $3,000. Luckily for her, she won the grant, but take note: She didn't do it alone. She relied on colleagues, professional groups, and a friend with writing expertise to help her brainstorm, edit, and find language to describe the power and dark humor of her work.

The first rule of grant writing is "Follow directions." And if you do nothing more impressive than this, your application will be better than most. What makes grant writing challenging, especially for the individual artist, is that it you need to write about your work as if you didn't create it. And that's tricky because it requires a shift in your point of view.

When I'm writing and am ready to reread what I've written, I stand up in my writing studio and walk around, reading my work aloud. When I'm done writing and need to edit, I print out the pages and go to another room or to a café to read and revise. As I change gears from writer and creator to editor and audience, it helps me to shift my perspective, by moving my body, hearing the words spoken aloud, even changing my physical location. This shift allows me to read my work as if I didn't write it.

Although you can write a proposal solo, your application will be much improved and the process of writing it much more enjoyable if you get others involved. Other people can provide perspective that is hard, if not impossible, to get on your own. Also, the more you practice strategizing, brainstorming, and editing someone else's work, the better you'll perform these tasks on your own application when you're working alone.

> Other people can provide perspective that is hard, if not impossible, to get on your own.

Teamwork has the power to propel one artist faster and further than he could go on his own. For artists used to working in teams,

like filmmakers, this approach is easy to envision. But regardless of whether you're a loner or a collaborative artist, make your next grant proposal a group effort.

Assemble Your Team

Every artistic project, including the next grant you write, is a group effort. Writers need editors, actors need directors, even the most solo artists need at least one other person to provide perspective. Before you begin your next grant proposal, assemble your team of "experts" or maybe just friends with particular skills and an objective eye. Team members you'll need are listed below, in the order in which you'll need them.

RESEARCH PARTNER • Researching grants can be overwhelming. To avoid a potential rabbit hole of research, join forces with another artist and both commit to spending a set amount of time researching grants. On your own, it's too easy to give up or procrastinate. For more details, see the "Schedule a Research Day" section in chapter 1 (page 16).

BRAINSTORMING PARTNER • Ask a colleague or friend to help you decipher application questions and brainstorm answers. Read the questions to your partner and ask, "What does this question mean to you? What are all the possible ways I could answer this?" Read the criteria aloud to your friend and ask, "Does this sound like me? Do I qualify for this grant?" Your brainstorming partner doesn't need to be another artist. Sometimes it's better if she's in a different field altogether.

INTERVIEWER • Enlist a friend or colleague to interview you about your project. This conversation helps you find the vocabulary to describe your ideas. Choose a friend who's naturally curious and a good listener. Again, pick somebody not in your field so that you'll be forced to explain ideas that you might gloss over with a fellow artist. Write

down your exact words and phrases or have a third person act as a "scribe" and take notes as you're talking. (How to use the interview to arrive at the core of your idea is detailed in the "Talk First, Write Later" section on page 42 in this chapter.)

I advise artists to write grants collectively. If seven people are applying for the Rockefeller MAP grant in San Francisco, get together and write your proposals together and read them to each other. It can seem kind of counterintuitive because everyone feels like they're competing for a small amount of money, but it just makes every proposal better, and that's what you want. It's much easier to see what other people are doing wrong than what you're doing wrong.

· AARON LANDSMAN, ACTOR AND PLAYWRIGHT ·

AUDIENCE • Interview your audience about what they appreciate about your work; they'll glimpse themes and connections you never considered. Let them help you find the language to describe your art. You can conduct interviews by e-mail, phone, or questionnaires. For details about how to solicit the most useful feedback from your audience, see the section "Interview Your Audience" on page 44 in this chapter.

TELEPHONE COACH • Before you call the granting agency, call your "telephone coach" first to rehearse the call. This exercise will help

you describe your project and ask your questions succinctly, and it will warm you up for the call. The more you practice, the easier it will be.

I always felt slightly embarrassed when I first rehearsed a call with my telephone coach, Dana, but not as embarrassed as I would have felt making the call cold. I also called Dana after the call to let her know how it went. Review what went well and what you wish could have gone better so you can improve your game the next time around.

EDITOR · The right editor is your most important team member. Enlist someone who is an excellent wordsmith to read drafts of your application. This person must be able to both pinpoint the strong sections and help you improve the weak ones. Always give your editor the list of questions you're answering so she can brainstorm with you on how best to answer them.

If your editor often says, "It's perfect, I wouldn't change a thing!" then you need to find a more experienced editor. On the other hand, if your editor is never pleased with any of your drafts and the critiques keep getting harsher, seek a second opinion from another editor.

Every artist and writer I interviewed for this book had at least one person read the application before submitting it. Artist Rita Robillard asks two people to read her applications: Her daughter, a travel agent, reads the rough draft to make sure Robillard is answering the questions on the application and that the writing is clear; a friend who is a professional writer does a detailed edit of her final draft.

To edit your own work or that of a colleague, follow professional editor Jill Kelly's example: "I keep in mind the assignment, such as the grant question, and I read for the clearest, best-organized answer to that question. I'm reading as if I'm the intended recipient of the application, and I'm looking for ways to strengthen the argument."

PROOFREADER · Have a fresh set of eyes proofread your application before you submit it. Remember that you're competing with other A-plus efforts. Ideally, the proofreader will be someone who hasn't

read your grant application before. A proofreader should have an eye for detail and check for typos, missing words, and misspellings as well as double-check the math in your budget. (See "Four Proofreading Tips" on page 76.) Misspellings may not disqualify you, but they make you look like an amateur. A budget that doesn't add up correctly is a big strike against you and could be a basis for rejection.

So you don't know how to write? Don't write. Do you know how to talk about your work? Get a little digital recorder and talk about your work. Oh, that's tough for you too? Well, draw me a picture about your work. Oh, that's tough too? Well, how about let's do a little play about your work. You find a way to express the work and then, with other people's help, you can codify it.

· MORRIE WARSHAWSKI, AUTHOR AND CONSULTANT ·

WORK SAMPLE ADVISER · Most grant applications require you to submit a work sample. Follow the guidelines for what format and how much to submit. Your sample must both feature your best work but also be the right match for the grant. Because you can't show it all, your adviser will help choose the strongest sample for this application.

Linda Hutchins hires a consultant she's worked with for years to help her choose her work samples. It's easier for another person to see the big picture and assess what's most important to show in the sample, she said. Before Hutchins could afford to hire a consultant, she asked her husband, sister, and a critique group for advice.

For more information on preparing work samples, read the interview with professional photographer Grace Weston on tips for photographing your artwork in chapter 8 (page 111).

Trade for Help

One way to recruit advisers is to barter, trading time (services) or products with other professionals. For example, I once received several hours of work from a graphic designer in exchange for home-cooked meals that I dropped off at his house. You might exchange services, hour for hour, or trade a piece of artwork for a few hours of time with a professional whose services you require.

The best people to trade with are those whose skills or personalities complement yours. For example, I have an introverted editor friend who hates to make phone calls to arrange readings and do public relations. I love talking on the phone and enjoy marketing. So, my friend edits and proofreads for me, and I make phone calls for her. We're a perfect match.

Be selective in choosing the people you swap with—as careful as you would be if you were paying by the hour. Just because a person's time is "free," doesn't mean it's worth it. The wrong help is worse than no help at all. Once you've found someone to barter with, start by exchanging one hour. See how this person works with you; see how you enjoy the help. If this person doesn't turn out to be someone you want to work with, don't trade any more hours. If you decide to continue, be specific about what you'll be bartering. You may even put it in writing or at least exchange e-mails about your understanding of the agreement. It's up to each "trader" to keep track of hours. Check in with each other weekly or monthly to see how much time each of you has spent to ensure your arrangement is equitable.

When considering a trade, ask yourself, *What expertise do I have that I would actually enjoy offering? What's a skill that I need most?* Devise an exchange that feels right to both you and your partner. And when the

trade no longer works, end it. Trades are not meant to last a lifetime. Maintain them only as long as they're useful to both of you.

As you would with any important partners, choose your team members wisely. Let your gut be your guide. Some colleagues will put down your ideas, no matter what. They won't think you're ready for any grant, ever. Sometimes it's hard to spot these wet blankets at first—and honestly, we can all be miserly and critical at times. So, an artist friend who helped you once may not work out the second time around. In any case, take the opinions of others with the requisite grain of salt. Good advice will ring true. If you get feedback you truly don't agree with, just say "thank you" and ignore it.

Sometimes your advisers will disagree with each other, and dissenting voices can make you feel more confused instead of more confident. (For exactly this reason, Hutchins uses only one adviser whose opinion she respects and trusts rather letting her entire artist group critique her grant application.)

Talk First, Write Later

One of the most important team members is your interviewer—the person you'll run to when you realize that it's impossible to find your way to the core of your idea without talking about it first. When you talk to a good listener, you say things that you would never write. When you speak, you use words, phrases, and a music of talking that is your unique voice. Talking about your project reignites your excitement and reconnects you with that glimmer of an idea long enough that it can grow.

> Talking about your project ignites your excitement and reconnects you with that glimmer of an idea long enough that it can grow.

Your interviewer doesn't need to be an artist or know your work. In this interview, you be the expert. Pick someone who can ask dumb questions and listen to you until the pith of your idea or project comes forth.

Ask your interviewer to use the following questions to jump-start your interview.

1. Can you describe, step by step, how you make your art, from concept to finished project?

2. Why did you choose this art as your form? What do you love most about it?

3. What is your earliest memory of making art? Where were you? What were you doing? Was anybody else there? What did you make?

4. Who in your life influenced you the most? a family member? a famous artist you never met? a teacher?

5. How did this influential person have such an impact? What did he or she do, say, or show you?

6. What is your idea for your next project?

7. How do you plan on making that?

8. How will this grant make your project a reality?

9. Why does the world need your project?

10. Who is your audience? Who are the people that are dying to experience this kind of art?

Interviewer Tips

The interviewer uses his or her best listening skills and asks simple questions, which often lead to the best answers. He or she shouldn't be afraid to let you flail a little but can rephrase a question or ask a simpler one if you seem to be having trouble. The interviewer

should be open to every word you say; the goal is to encourage you to talk.

When I interview someone, I try to put myself in a "dumb" state of mind where I question everything that doesn't make sense to me or that I think the artist has skimmed over. In most interviews, the artist begins talking about her project in a very general way. I pay attention to my feelings as I'm listening. When I feel bored by her answers, I use this as a clue that she's not getting to the hot center of her idea; when I feel excited, I take this as a sign that she's close to what's compelling, important, and unique about her project and her passion for it.

Simple questions help an artist keep digging. You may feel frustrated, even angered by your interviewee's questions. Then suddenly you'll say, "You want to know what my project is about?! I'll tell you …" and spill it: a beautiful description of the heart of your idea.

Interview Notes

If possible, have another person, not the interviewer, take notes as you talk. This person should be able to write quickly and legibly or be a skilled typist. It's not necessary to transcribe everything you say. Record the single words and phrases that capture the idea best.

If a note taker is not available, consider tape-recording the interview and transcribing it later. Test the recording device beforehand, so you know that it's capturing your voice clearly.

Interview Your Audience

Another way to develop the material that you'll use to answer your application questions is to interview your audience. People who know and love your art can provide you with a wellspring of information about what viewers gain from experiencing your work.

Interview your audience over the phone, in person, or with an e-mail questionnaire that asks specific questions. Choose audience

members who know you and like your work. You're not looking for a critique in these interviews. You want to find out how, why, and what your audience appreciates about your work. Their answers may give you new ways to express your themes and the impact you have on viewers.

Interview both colleagues and nonartists. Sometimes nonartists provide the best comments because they don't use lingo and don't feel they have to give smart answers. Don't be shy about asking people—most people are flattered to be asked and enjoy offering comments.

At one of my solo performances, I had ushers pass out comment forms before the show and collect them afterward. These cards were a great way to chronicle the evening, and I received useful feedback that I incorporated into future shows and kudos that I might never have heard otherwise.

Phone or In Person

When you interview someone in person or over the phone, listen to their answers and write down all comments—positive, negative, and neutral. This interview is a time to listen and encourage them to talk; it's not a conversation. It's definitely not a time for you to explain or defend your work. If an audience member asks a question during the interview, write it down and say, "Thanks for asking. I'll have to think about that. I'm here now to listen to what you have to say." Then move on to your next question.

Pretend you're an anthropologist gathering data from your tribe. Don't judge the answers; simply collect them like a scientist working in the field.

E-mail

If you decide to conduct your interview via e-mail, send each questionnaire separately and address each e-mail personally; don't send a generic e-mail to a long list of recipients. Most people hit the delete key when they receive a mass mailing. First send a message

to each person asking whether he or she is willing to fill out a short questionnaire, then send it as a follow-up. Make this process as easy and fun as possible.

Sample Questions

Use the following sample questions to jump-start your interview with your audience. Choose the questions that best serve your purposes and will provide you with the answers you want. Rewrite these questions as needed.

1. After you've seen my work, what questions do you have? insights? feelings?

2. What does my work make you wonder about?

3. What about my work is disturbing? intriguing?

4. What do you see as the unique strengths in my work? What makes my work special or different from that of other artists doing similar work?

5. If you were describing my work to a nonartist friend who had never experienced it, what would you say?

6. What do you enjoy about my work? Why would you recommend that a friend go and experience it for himself?

your assignment

E-mail or call a colleague and ask for help with one aspect of preparing your next grant proposal. Offer to help her do the same. Asking for help is not easy; let the grant-writing process help you practice.

gigi's cheat sheet

- Don't go solo; enlist a team to help you write your next grant.
- At a minimum, recruit one person to edit your rough draft and proofread your final draft.
- If you can't afford to hire help, arrange a win–win barter.
- When editing your own work, read it aloud, print it out in a different typeface, or move to a new location like another room or to a café.
- Recruit an adviser to help choose the highest-quality work samples that are the best match for the grant.
- Sometimes the first step to writing is talking to a good listener. Ask someone to interview you about your project idea.

4 • decipher the applications

Grant writing isn't hard like metaphysics is hard. Take it one question at a time, and don't be shy about asking for help, first from your team and then, if necessary, from the funder.

By now you've done your homework and imagined where you want to be in a year, or three, or ten. You have a list of what you need today to take you to that future. Your list may include a residency, a fellowship, a project grant, or a professional development grant. You've gathered a support team and have brainstormed and interviewed people to help you articulate your view of yourself as an artist.

You also may have downloaded some applications and may be confounded to notice that no two applications are exactly alike.

For example, government grants usually provide an application form with questions and boxes in which you'll fit your answers. Foundations often request a list of items that comprise a proposal: project description, résumé, budget, and so on. For example, the Ruth Chenven Foundation asks for a one-page artist statement, a one-page project description, and a one-page description of your work sample. There is no application form to fill out.

The Basic Elements of a Grant Proposal

Preparing a grant proposal is easier when you have an application form, because the instructions are detailed and you aren't left to wonder what the budget should look like, for example.

When no application form is provided, you'll likely be asked to prepare and provide some or all of the following materials.

LETTER OF INQUIRY • A funder may request a letter of inquiry as a prerequisite to a full-fledged proposal. Focus on summarizing key points of your project and why you believe it's the right fit with the grant. If at all possible, make personal contact with the foundation before sending this letter, and float your project idea by a program officer to gauge whether it's in line with the funder's mission. This contact will also put a face on your proposal.

COVER LETTER • Although the funder reads the cover letter first, write it last. This letter—one page, maximum—is both an invitation to join you in your project and a summary of what you intend to create. It states your request (What do you want? What will you do with the money?), introduces the funder to both you and your project (What is your unique experience? Why is the project needed? Why are you and your project a good match for this funder?), and references every document or other enclosure in your application package. Address the cover letter to the appropriate person, and confirm the correct title and spelling. As always, conclude with thank you.

> To get it right, the artist must answer the question so it's really
> clear that he or she has respected our process enough to read
> and follow our application instructions. That's a really mundane
> point, but this gives the artist points for clarity. The second thing
> that makes a difference is when it's apparent that the applicant is
> proposing a project that's related to his or her artistic career goals.
>
> · SHANNON PLANCHON, ASSISTANT DIRECTOR,
>
> OREGON ARTS COMMISSION ·

Not every proposal needs a cover letter, especially if the application includes a specific cover page to fill out. Provide a cover letter if requested or if you need to submit additional information that could not be listed elsewhere on your application. You might include a cover letter if you want to mention a specific program officer at the foundation who discussed your proposal with you or if you want to note that you're a past recipient of funding from this foundation, for example.

EXECUTIVE SUMMARY OR ABSTRACT • This short document (from two paragraphs to one page long) summarizes your proposal. Choose the most striking aspects and important details. It's the short answer to who, what, where, when, why, and how. Write it after you've written the entire proposal.

PROJECT DESCRIPTION • The project description is the story of your project. It's the who, what, where, when, why, and how. Include details

about your goals for the project, why your project is needed, and exactly what your project entails. Unless your audience is addressed in another part of the application, specify the audience your project serves. Format the document with headings, subheadings, and short paragraphs so the entire proposal is easy to read and navigate. See chapter 4 for details about developing your project idea and describing it so that others can embrace it.

BIO AND RÉSUMÉ • If you're just beginning your career, a short bio may be all you need to describe your background, education, awards, publications, and so on. Tailor your bio and résumé to each grant you're applying for, including only background and qualifications relevant to this project and this funder. Chapter 7 provides instructions on how to write them and an example of a bio.

ARTIST STATEMENT • The artist statement speaks for your art and explains why you make it; it's your philosophy and your manifesto. Chapter 7 provides examples and detailed instructions for preparing your statement.

BUDGET • A budget lists the expenses (from labor to office supplies) and income of your project (money from grants, fundraising parties, and in-kind donations) in detail. Chapter 9 details how to create and flesh out a budget.

WORK SAMPLE AND WORK SAMPLE DESCRIPTION • Your work sample is exactly that—a sample of your work—and can be presented in text, images, multimedia DVDs, audio CDs, and so on. Choose work samples appropriate to your project and the funder, and ensure that they are of the highest quality, even if that means hiring a professional photographer or videographer to document your work. A description sheet details the work sample: type of project, title, published or completion date, and so on. If you submit several samples, number each one and cross-reference the sample numbers to numbers on

your description sheet. See chapter 8 for details on how to assemble a kick-ass work sample.

SUPPLEMENTARY MATERIALS • Supplements can include newspaper, magazine, or journal articles; exhibition publications; postcards from a show; or any other documentation of your work. Include any good-quality documentation that supports your project unless the funder has specifically asked you *not* to include anything extra.

TIMELINE OR SCHEDULE • Your timeline or schedule lists the dates that activities will occur if funding is granted. List the activities by date, in chronological order, from beginning to end. Every activity listed here also should be mentioned in other parts of the proposal. A complete timeline or schedule demonstrates your thorough and thoughtful planning.

LETTERS OF RECOMMENDATION • If recommendation letters are requested, choose people who know your work and your successes and, ideally, people who will impress the panel. Give your letter writers ample notice when requesting a recommendation; a month before your deadline is best. Ask them whether they feel they know you well enough to write a strong letter, and if they don't, look elsewhere—you want recommendations from people who feel enthusiastic about you and your work. Offer to help your letter writers by sending each one a fact sheet with pertinent dates and information to include in the recommendation letter: when you met, when and where you worked together, and what you produced. Include a draft summary of your proposal, a copy of your résumé, and your website URL for reference.

Typical Application Questions

Applications for grants are as diverse as the organizations that offer them. The number of questions you'll need to answer and amount of writing you'll need to do will vary with the type of grant and type of

organization. As you grow as a grant writer, you'll realize that most applications ask the same questions, even though they may look different at first glance.

An application for a project grant requires the most work on your part because you're proposing a project that doesn't yet exist. Not only do you have to describe it but you also have to prove that you can successfully create what you haven't yet made. A project grant application usually asks questions that address:

Most applications ask the same questions even though they may look different at first glance.

- Project description
- Intended audience
- Goals for the project
- Plans for evaluating success
- Description of collaborators
- Marketing plans

When you apply for a professional development grant, which is designed to advance your career, you have free rein to be completely selfish about your professional goals. Explain how this workshop, research trip, or work with a mentor is the best way to take your career to the next level. A professional development grant application usually requires that you describe and include several basic elements:

- The professional development opportunity
- Artist statement and bio
- How this opportunity will impact your career
- The planning and research that went into your proposal

Applications for fellowships and residencies tend to be the shortest because they usually are awarded on the basis of your work sample. The writing is no less important, but the applications do ask fewer questions. At a minimum, be prepared to provide the following materials:

- Artist statement
- Project description
- Stellar work sample

Make Sense of the Questions

The first time I glanced at the number one question on a grant application and read, "Describe the main concerns of your work. You may discuss your intent, your artistic development, or your ..." I broke into a sweat. I heard my heart pound in my ears. I didn't understand the word intent, I wondered what artistic development meant, I worried that I'd never felt "concern" for my work.

The only difference between that first experience and now is that now, I expect the questions to confound me the first time I read them. So, I start by picking the questions apart, piece by piece, and rewrite them in my own words so that I understand what's being asked. I read them to friends and colleagues and ask, "What does this question mean to you?"

If a question asks about my development as an artist, I look to my artist statement. If I didn't include much about my development in my current statement, I'll brainstorm all the different ways to discuss development. For example, I can outline my education, both in school and in the world, or talk about how I was drawn to this art form and how my childhood passions led to my current path. When I get stuck with every hard question, I brainstorm on my own and with colleagues.

If you don't understand a question, either what they're asking or how to answer it, you can ask a colleague for help, interview an artist who has won this grant before, or call the granting organization for guidance.

As you proceed through the application, keep a list of questions. Some may be answered as you go through the writing process.

Answer the Questions They Don't Always Ask

Some applications ask detailed questions; some don't. The more specific the questions, the easier it is for you to describe yourself, your project, and your plans. No matter what the application asks, consider incorporating answers to the following questions into your proposal.

HOW IS YOUR PROJECT UNIQUE? • Most funders like projects that solve a problem in a new way. How is your solution different from what's been done already? What have you thought of that nobody else has? How does this project break new ground? What makes your project special?

HOW IS YOUR PROJECT TRIED AND TRUE? • Aha! But if it's so new and so unique will it work? What aspects of your project already have been successful? How will you ensure success? Who on your team has the experience and knowledge to guarantee it?

HOW IS YOUR PROJECT NEEDED? • What will it do for your audience? How will it meet the need you've identified? How will it meet that need in a way that differs from previous attempts? What will your project do that others haven't done?

WHY DOES THE WORLD NEED YOUR PROJECT RIGHT NOW? • Why can't it wait? How is this project perfectly timed for where you are in your career? (This question is especially important to answer when you're seeking a professional development grant.) An urgent, well-timed project is most likely to receive funding.

WHY ARE YOU THE PERFECT PERSON TO UNDERTAKE THIS PROJECT? • Granting agencies want to fund the right person. How have your life and career led up to this moment? What do you bring to this project that is unique and vital? What makes you perfectly suited to carry it through? Your answers to this question add interest, excitement, and the right kind of urgency to your proposal. Tell the funder how and why you are the right person to create this unique, necessary project, right now.

HOW DOES YOUR TEAM SUPPORT YOUR BIG VISION FOR THE PROJECT AND ENSURE ITS SUCCESS? • Why are they the perfect collaborators? How do their talents dovetail with your strengths? How did you pick your team? How is the team working together on this project? How will you ensure that your big vision for the project is maintained?

Describe Your Project

Grant writing challenges you to write about a project that doesn't yet exist. But how do you describe a project that is still only a glimmer? You have a hunch you need a travel grant, an inkling you need a mentor, a desire for a fellowship, an idea about a performance piece.

Rita Robillard, a mixed-media artist who's won more than $75,000 in grants over the course of her thirty-year career, does this "by pretending I know what I'm going to do before I've created the work." This isn't as hard for her as it sounds because, like many artists, her next project is never totally new—it's always an extension of what she's been making.

You already have within you a kernel of your new direction. Your task now is to unearth it, unwrap it, and express it in writing that is concise and passionate. The first step of this assignment isn't necessarily writing. It's strategizing, brainstorming, having conversations, listening to your audience, and talking to trusted colleagues.

Visual artists sometimes have trouble imagining how a painting can be a "project." It's easier for a theater artist or a musician to see

his or her performance event as a project. If you can't envision your art as a project, remember that even a "series of paintings" can be a project, especially if it culminates in a public showing. Don't assume that because you're a painter or photographer, you'd never have a project. On the websites of most funding organizations, you'll find a list of who's been funded with a short description of the project. Investigate the projects that other artists have created—you may be inspired by what you find.

> ● ○ ○
>
> You already have within you a kernel of your new direction. Your task now is to unearth it, unwrap it, and express it in writing that is concise and passionate.

If you're having trouble writing about your project, visual artist Mark R. Smith advises newbie grant writers to first construct a model especially if you're proposing anything three-dimensional, like an installation. Building a model will help you visualize it so that you can write about it more convincingly.

Nail the First Sentence

In the first sentence of your project description, describe exactly what your project is. Your readers need this anchor early on. Kemi Ilesanmi, director of grants and services at Creative Capital, told me that the panelists reviewing grant applications often don't have a clear idea what the project is. "You kind of understand that it's dealing with environmental issues, for example, but you don't know if it's a dance piece or a photograph," she said.

In this important sentence, include the medium, the title, and a short description of your project. The following four examples are first sentences from successful grant proposals:

- "For my upcoming solo exhibition on October 1, 2009, at Lawrimore Project in Seattle, I intend to make a sculpture that

references the near-fatal Que Creek mining incident." —Leo
Berk, sculptor

- "The House Project is a site-specific movement piece that
will take place in June 2007." —Tracy Broyles, dancer and
choreographer
- "I am proposing a HARP residency to create a new theater
work called *City Council Meeting*, which will feature (at least)
nine characters as well as live video and a webcast." —Aaron
Landsman, actor and playwright
- "I propose to enroll in the International Voice Workshop
with instructor Richard Armstrong at the Banff Centre in
Alberta, Canada, for an intensive three-day workshop in August
2004." —Gigi Rosenberg, writer

Example project descriptions for two of the above statements
(both of which were excerpted from successfully funded grant appli-
cations) follow.

PROJECT TITLE: QUE CREEK SCULPTURE
ARTIST: LEO BERK, SCULPTOR

For my upcoming solo exhibition on October 1, 2009,
at Lawrimore Project in Seattle, I intend to make a sculpture
that references the near fatal Que Creek mining incident. In
July of 2002, nine miners became trapped inside the Que
Creek mine after they inadvertently excavated a hole into a
neighboring abandoned mine that was filled with water. In a
matter of hours, the Que Creek mine filled with nearly 50
million gallons of water, trapping the nine miners in a small
pocket of air over a mile away from the mine entrance. They
remained in cold and darkness for over 3 days, writing letters
to their families to say goodbye.

In the most amazing successful mine rescue ever, all
nine miners were saved by a rescue crew hypothesizing their

location in the mine and drilling a 24-inch rescue hole 240 feet below the surface in order to hoist them to safety. The rescue drama unfolded in the headlines of all news media and galvanized the country in a positive direction in the dark times following the 9/11 terrorist attacks.

My sculpture will be a large-scale, abstracted model of the Que Creek mine. Using the published MSHA [Mine Safety and Health Administration] accident investigation report as reference, I have created a 3-D digital model of the complex mining structure. The actual mine was miles in length, yet averaged 4 feet tall. My sculpture will maintain the scale of these proportions resulting in a thirty-foot-long sculpture that is ¼" thick. It will be CNC-cut from colored acrylic sheet using the digital file I have created and stand on thin aluminum legs so that it hovers between 3 and 4 feet off of the ground. Please refer to the rendering of the sculpture in the gallery space supplied in the work samples.

This sculpture will be the centerpiece of my Lawrimore Project exhibition. The show will deal with a broader theme of underground spaces ranging from caves to smuggling tunnels to hideouts.

PROJECT TITLE: THE HOUSE PROJECT
ARTIST: TRACY BROYLES, DANCER AND CHOREOGRAPHER

The House Project is a site-specific movement piece that will take place in June 2007. Set in an actual home, the work centers around three performance installations through which the audience is guided by a chorus in the tradition of Greek Theater. The work is the culmination of my research into the Sybils (Greco-Roman cave-dwelling oracles) and the writings of Carl Jung.

The house serves as a metaphor for the collective unconscious, and the viewers are guided through the home to physically recreate their own psychic journeys. The installations represent the body/mind states that the Sybils would cycle though, with a solo performer choreographed into each of the following: a bathtub; a pile of dirt under a hanging tangle of branches; and a room filled with paper leaves, video projections, and white cloth.

I am the choreographer, Nicole Linde/Brittlestar is the video artist, Malina Rodriguez is the lighting designer, and David Todd/Roots Realty is providing performance space. Dancers will be chosen through an audition process in January of 2007.

Know Your Target Audience

Who are the people desperate to experience the art you make? Who lives for this type of experience? How will you reach them? Where do they hang out and find out about events like yours? Many newbie grant writers make the mistake of proclaiming that the work is "for everybody, from babies to seniors." This is rarely true. And that's not a problem. The narrower your audience, the easier it is to define and reach it.

Some organizations care very much about the audience your project will touch. Others don't. If you're applying for a fellowship to support future work, you may not need to address your audience at all. However, if you're applying for a project grant from a funder who cares about who will experience your work, how you'll reach them, and possibly even how you'll expand your audience, then you will need to know your target audience well.

If your funder cares about reaching beyond the usual suspects who show up for artsy events, offer a creative marketing strategy to expand your audience in innovative ways. First, identify your audience, then be specific about how you'll reach them. For example, if your solo

show is about surviving cancer, you could create a plan to reach out to people affected by the disease who otherwise might not attend theater performances or visit galleries. Next, show the funder that you've done your homework by citing numbers to support your proposal. Which groups are you collaborating with? How exactly will you reach this audience? It's not enough to say you'll send some e-mails and tack up some posters; how many e-mails? How many posters? The specifics help you make your case.

Highlight your past successes. How many people have attended your events? What marketing methods have you already used successfully? What relationships have you already forged with collaborators?

Track Deadlines

Give yourself six to eight weeks to prepare your grant application. You won't be working full time for that long, but you'll need ample time to research, consult with colleagues, prepare your work samples, and write and edit your answers on the grant application.

Make a note as to whether the grant deadline is *the date you need to mail the application or the date it needs to arrive at the funder's office.* Grantors usually specify how they want to receive their applications. Some want them submitted online, while others want them mailed. Some want several copies. Some specify paper clips versus staples or three-hole punches. Take note of these details up front so you don't have any unpleasant surprises at the eleventh hour.

Murphy's Law applies to all grant writers who are scrambling the last day. If the grant application must be submitted online, the funder's Web server will be so overwhelmed that you might not be able to get through. If you go to photocopy the application, the machines will be out of order. To avoid a last-minute panic, aim to submit your application a week early—then if you fall behind by even a couple of days, you'll still make—if not beat—the deadline, without the drama.

your assignment

Describe your project in one sentence: what it is, what art form, what medium, when and where it is scheduled to be seen. Practice using this sentence when describing your project to a friend or colleague who doesn't know what you do. When you're done, ask your friend to tell you, in her own words, what your project is. If she can't do it, go back to the drawing board and try again; if she can, congrats, you've done it.

gigi's cheat sheet

- Remember that the people who will read your grant application don't know you and have no idea what you do.
- Always answer the who, what, when, where, why, and how, even if the application doesn't specifically ask these questions.
- Make personal contact with the funder before sending a letter or proposal.
- Consider the timing of your project: Why does the world or your career need it now?
- Consider your contribution: Why are you the only one to carry this through?
- Make sure the first sentence of your project description states what your project is exactly, without room for misinterpretation.

5 • write your proposal, step-by-step

Writing captures your pie-in-the-sky idea, brings it down to the ground, and makes it real.

t's impossible for most people, even writers, to sit down and hammer out a grant application in one sitting. A proposal is a creative project like any other. You wouldn't expect to finish a painting or complete a short story on the first pass. It takes many false starts, many working sessions to gather your raw materials, write, revise, reconsider, and polish.

After you've read the application questions, your mind will work on your answers as you go about your daily life. Purchase several small notebooks or index cards, and place them with pens in strategic places throughout your life: in your glove compartment, in your backpack, by the phone, by your bed, in your purse. This is what I love about being a writer:

I'm a writer even when I'm not writing. I'll be in on a bike ride when a phrase describing my work pops to mind or I'll think of a business I can call to request a donation. When this happens to you, write these ideas down. Not all of them will pan out, of course, but many will. The more I write my ideas down, the more I signal to my subconscious mind, *Great ideas! Please send more.*

> I give my writing a long time to germinate. I cut and paste all kinds of ideas and let that sit. Then a week later, I'll read it and usually know what to take out, what to add, and what needs more research on contemporary art history.
>
> · BONNIE COLLURA, SCULPTOR ·

Experienced writers may jump to writing the first draft of their grant proposal immediately. However, many grant writers need to talk out their ideas first. If that's the case for you, review the "Talk First, Write Later" section in chapter 3 (page 42) to find out how to interview others and be interviewed to find fresh language to describe yourself and your work.

When you're ready to write and would like to use the writing process to explore and expand your project idea, consider using the freewriting method.

Freewrite Your Way to the Big Idea

A freewrite is a timed writing exercise designed to help you capture your unique voice. The only rule of freewriting is that you keep writing

for the entire time, which can be as short as ten minutes. A freewrite works because you're free to write yet constrained by time; the time limit makes the writing process less scary. To keep writing no matter what, you'll have to write down whatever pops into your head, which may be exactly the juicy material you need.

To start your freewrite, gather lots of paper, your favorite writing instrument, a kitchen timer and a "prompt." A "prompt" provides focus and a beginning. A writing prompt can be a question, a photograph, a painting, a poem. The prompt jumpstarts your writing and encourages your hand to move and the words to come. A freewrite prompt can come from a grant application ("Describe your artistic development") or even an image (*How does this image remind me of what my project is about?*).

Write nonstop for ten minutes. Don't stop writing until the timer goes off. When the ten minutes are up, you can call it a day or write for another ten minutes, using the same prompt or another one. You can do several ten-minute freewrites in a row.

After you've finished, don't read what you wrote. Put the freewrite in your "Raw Materials" folder and move onto the rest of your day. Over the days or weeks you're working on your application, write as many ten-minute freewrites as you can until you feel you've asked yourself all the questions on the application. Not all of what you write in a freewrite will be useful, but often enough you'll discover some gems.

Write a Lousy First Draft

To begin your draft, first lower the bar. Call it a lousy first draft. That helps relieve the pressure you may feel to write something complete and perfect. A first draft is by its very nature, incomplete and imperfect, even lousy.

Example of a Freewrite

○ ● ●

The assignment I gave visual artist Linda Hutchins and other attendees in one of my grant-writing workshops was, "Write for ten minutes non-stop about any inkling you have about your next project." Below is an excerpt from Hutchins's freewrite that shows her first thoughts and the edits she made later. This freewriting exercise became the basis for her artist statement reprinted in chapter 7 (pages 95–97).

My initial idea was to do a suite of engravings: lines, lines, lines, a continuum of lines filling the copper plate, transferred to and embedded in the paper through the printing process, ~~inking the plate, pressing the plate into the paper.~~ The lines are carved—engraved into the copper with a tool called a burin, ~~a curl of copper~~—plowing ~~a curl of copper—~~a thin curl of copper ~~that curls~~ in front of the tool, ~~throwing off a sharp curl of copper.~~ But I'm worried about my hand, and the damage of repetitive work, and wanting to get to some other less repetitive, less damaging process that will still get the same result.

What is the result I'm after? It has to do with daily detail, generational recurrence, and repetition, the things we do again and again that our parents did again and again, that their parents did again and again, that we all do again and again. The tedium that ties us to our forbears. ~~Or not.~~

Now I am thinking about the silver spoon. My parents ate with silver spoons. Their parents ate with silver spoons. I have silver spoons that are engraved with the initials of both my grandparents. I have silver spoons ~~that are not engraved with my own parents'~~

~~initials but~~ *that we ate with every day of my childhood. They've been in my mouth and the mouths of my family. I want to transfer that silver to a surface, a surface that I have embedded with my own fingerprints, shaped with my own fingers, and rub into it the silver that has touched the tongues of my ancestors.*

Notice how even her worries led her deeper into describing her next project. Of course, she edited out the worries later. But the jewels in this freewrite sparkle, even in its rough state.

The first step toward writing a lousy first draft is to gather your raw materials. They may include the following:

- Notes from interviews you've done with audience members
- Notes from interviews others have done with you
- Reviews of your work others have published
- Past grant applications
- Your artist statement and bio
- Any other writing you've done about your work

Grab a highlighter, and while you read through all this material, highlight the words, phrases, and ideas that resonate with you. This is a process of listening to your gut.

Before you write that lousy first draft, you may outline your answers. An outline lists your key points in more or less the right order. The advantage of an outline is that it helps you feel secure in your writing; you know where to start and what's next. The only drawback to an outline is that sometimes you don't know what you want to say until you actually write it. So, in some cases, you won't write an outline until after that lousy first draft. Then, the process of writing the outline helps you figure out what's still missing in your answer.

Next, set a timer for ten minutes. (Once you get going, you can always write for another ten to twenty minutes. If you're experiencing a lot of resistance, ten minutes of writing may be all you can handle. That's fine.)

Cull through your raw materials. Using the words and phrases that you've already highlighted, begin to answer the first application question. Get every word and idea down on paper. Don't worry about spelling, grammar, or vocabulary, or creating a poetic or brilliant work. Don't be concerned if you sound like a caveman. Remember, your goal is to write a lousy rough draft that you'll never show to anyone. Let it rip—write it down however it comes out of you.

If you're experiencing major resistance, call or e-mail a friend; tell her you'll be writing for twenty minutes (or whatever time you choose) and that you'll call or e-mail her when you're done. Tell her your goal is to write a very bad first draft. Are you capable of writing a very bad first draft? Yes, you are.

If you still can't write, try this: Sit with a friend and talk out your answer while she writes it down. She's not necessarily interviewing you, just transcribing your thoughts. Don't worry how bad your answer sounds; just talk. The results will be your first-draft answer.

After you have answered one question, put it away. Don't even reread what you wrote—or if you can't restrain yourself, refrain from any self-judgment. What looks hideous in the moment may glimmer the next day.

Repeat this process over time for all the questions on your grant application.

Write a Better Second Draft

The longer you leave your first draft in a drawer, the better. Overnight is a minimum. This is why it helps to have two months to work on an application.

However, the day will dawn when you'll take that first draft out of the drawer. Read your possibly lousy first draft and highlight the

> ● ○ ○ ◯ ● ○ ○
>
> When funders read hype, they just yawn. Cut the adjectives and be matter-of-fact.
>
> · HELEN BORTEN, RADIO WRITER AND PRODUCER ·

places where you describe your project well, where your explanations are clear, and where you're answering the question. Have you included all the information you need? You inevitably left out a detail, so add it.

At this point, you might outline a revised answer culling the ideas from your first draft and adding new ideas or missing information.

Next, write a second draft using the best parts from the first draft and new information. Cluster information together that belongs together. Answer the question in the order the application asks for it.

By now your answers are sparkling with some real gems and have sections that feel true to your work. You've explained better what you're aiming to do and how you will ensure your project's success.

Proceed to Draft Three

After the first draft, the third draft is the hardest to write. One moment you think your writing is brilliant; the next moment it won't make any sense to you.

Check how much space is allotted for each answer. At this point, it's fine if your writing is a little too long. If you have only a paragraph and the grant application allows a whole page, go back and write more to flesh out your answer. If you've written two pages when you only need two sentences, revisit your answer and whittle it down to its essential parts.

Good Writing Principles

As you write and rewrite, consider these tips to hone your most specific, concise, and powerful voice.

Risk simplicity. Don't hide behind complicated and indecipherable language. Avoid jargon and big words when simpler ones suffice. Imagine you're describing your project to a smart sixth-grader. Be straightforward and unpretentious.

Be personal. If this is challenging, write about your project as if you were writing a letter to a close friend who doesn't know the details. Imagine a specific person; you can always edit out details later.

Use concrete nouns and active verbs. Use nouns that describe what you mean specifically, not generally. If you mean "horse," don't write "animal"; don't use "get" when "grab" nails your exact meaning.

Write in the future tense. Avoid the conditional tense, which makes you sound unsure. For example, rather than writing "My project *might, could, should,* or *would* … ," write "My project will … ." This simple change transforms your proposal from a pipe dream to reality.

Edit out qualifiers. Words like *really, sort of, kind of, slightly, overly* should be deleted, if possible. Your writing will be (sort of) stronger without them.

Learn and use transition words and phrases. Transitions like *therefore, nonetheless,* and *what's more* create more coherence in your writing.

Beware of mistakes that spell-check won't find. Some examples are these commonly confused words: *they're, their,* and *there; to* and *too; you're* and *your;* and *its* and *it's.*

Don't overuse adjectives. One descriptive word is usually more powerful than three.

Avoid passive voice whenever possible. Active voice creates more dynamic writing. For example, "My blog is followed by hundreds of

readers" is passive (less effective), while "Hundreds of readers follow my blog" is active (more effective).

Use the funder's terminology. For example, if an executive summary is requested, don't provide an abstract.

Follow guidelines to the letter. Pay special attention to requested word or character counts. Some rules may seem arbitrary—even Kafka-esque—but look at it from the funder's point of view: They're reviewing hundreds of applications, and their job is much easier when applications follow the same format. Also, following their directions demonstrates that you understand their concerns and respect their process. Failing to comply may disqualify your proposal.

Make your application easy to navigate. Leave ample (at least one-inch) margins; use headings, bullets, and even italics on key points; and choose a type face and size that are easy to read (twelve-point Times is a commonly used combination). Panel members are reading for sound bites; organize your application so your main points are easily noticed. But don't go overboard. Too many **bold** or *italicized* words will detract from, not enhance, your application. When in doubt, simplify. (Note: Some applications clearly prohibit specific formatting.)

Enlist a Reader

When you have drafted responses that are the right length and answered all the questions on your grant application, it's time to let a team member help you: a reader. You can read your answers aloud to your reader or let him read your answers and make notes.

If you choose to have the reader read silently to himself, you'll likely be writhing in agony across the table from him. Don't sit there and suffer. Go walk the dog, take a shower, reorganize a desk drawer in another room, or do the dishes—whatever is necessary to take your mind off the fact that you feel like you're about to be burned at the stake.

Sharing what you've written with another person can be excruciating and you'll want to skip it. Yet, it's the most helpful step of all. Do not wait until the night before the grant deadline to let another person hear or read your statement, because by then, it'll be too late to benefit from the feedback.

Instructions to Your Reader

A reader's job isn't easy, but the process truly helps a creative soul do the hardest work she can do: articulate her ideas and get her work out into the world.

Tell your reader specifically what kind of feedback you want. For example, "I want to know if the ideas are clear and if anything is missing or confusing." If your reader is new to the critique process, suggest that he follow some of these guidelines:

- Indicate which places in the writing are working best—where the ideas are clearly expressed and make sense to you.
- Note questions, and highlight areas that are confusing.
- Read over the application questions. Has the writer answered the "who, what, why, when, how, and where" questions? What's still missing?
- Mark the places where you feel most excited (which often means that the writer is hitting her stride).
- Mark the places where you feel bored or disconnected from the project (which can be a sign that the writer has slipped into jargon or is avoiding the heart of the idea).
- Pretend you're the funder: Would you fund this project? Why, or why not? What's missing? What hits the mark?
- Do the words paint a picture in your mind's eye? Could the writer add any sensory descriptions (sights, sounds, smells, tastes, or feelings) that would help?
- When you meet with the writer to provide your comments, greet her with a smile. Begin with a positive comment, along the

lines of, "Your project sounds amazing," "This proposal is really shaping up," or "Many parts of this application are good." Don't lie, because she can spot a liar; find at least one true positive thing to say.

- Proceed with your critique, listing your questions, areas of confusion, and any places where information was missing.
- End your critique with another positive comment, or repeat your first one.
- Tread lightly, praise profusely, and then critique honestly but kindly.

Write Your Final Draft

You may hate your reader after this read; this is normal. I fantasize about filing for divorce after every time my husband reads one of my rough drafts.

Wouldn't it be great if your reader said, "It's perfect. I wouldn't change a word!" If your reader says this, it might be true, but more likely you have a reader who's not skilled enough to help you. Get another reader. Your goal is to find a kind but also a *critical* reader. If you've selected a good reader, you'll hear words of praise as well as comments that may be painful, both because they're critical and because they mean you have more rewriting (and maybe fresh thinking) to do.

Edit out the weak verbs like "try" and "hope." Artists are afraid they'll sound like braggarts, but people don't want to buy paintings from people who are "trying" and "hoping."

· CAROLL MICHELS, CAREER COACH, ARTIST ADVOCATE, AND AUTHOR ·

Refrain from arguing with your reader. Just take his comments and thank him for his time. (This may require more self-control than you can imagine.)

Let all comments rest at least overnight before you begin the next rewrite; don't attempt it immediately after a critique. If you must keep working, give yourself a long break—a walk outside or a meal. When you begin the final rewrite, decide which of your reader's comments to address (and which to ignore), brainstorm more information where needed, and clarify confusions.

Edit the Final Draft

The final edit is the last step in polishing your proposal. Double-check spelling and grammar, cut excess words, and ensure your answers are the right length. Don't feel compelled to fill the whole space on the grant application form; if you've nailed the questions and have a little space left over, that's good. Above all else: Make sure you answered the question.

Four Proofreading Tips

1. If you proofread your own work, print out your document using a different typeface than you are used to reading. It's easier to spot mistakes when you reread the document in a different form.

2. Read the document backwards, sentence by sentence, from the end to the beginning. That way, you focus on each sentence as a sentence and not as part of your argument.

3. Whatever you do, don't rely only on your computer's spell-checking and grammar-checking features. They are not as smart as a good reader and will not identify dumb mistakes.

4. Verify the spelling of all titles and proper names.

You'll need your reader again, or perhaps a new one. If you do use a new reader, explain that you're not open to doing a total rewrite at this point, unless you have the time and motivation for it.

When I'm working alone, I read my answers aloud to myself, which helps me *hear* my answers. Actor and playwright Aaron Landsman takes this practice a step further: "I read my proposal in a fake accent that makes me feel silly or read it like a newscaster. Because what I trip over when I read it like the ten o'clock news often indicates there's something wrong at that spot, either dramatically or just expressively."

If this is your first time through the grant-writing process and you've followed the steps in this book up to this point, you've likely written a proposal that is much better than most. Congratulations.

your assignment

Celebrate. You made it up and over the steep hill. You're on your way as a grant writer and have a clear idea of not only what you want but also how to express it succinctly. Do something ceremonial. A writer friend of mine bought a "woman's wand" at an art show to wave over her application before mailing it. At a minimum, give yourself a treat: Take the dog on a long walk, meet a friend for coffee, go for a pedicure. You did it.

gigi's cheat sheet

- Once you've read the application questions, take notes as your ideas percolate.
- Use the freewriting process to find new ways to describe your project.

- Highlight and recycle sections from past grants to reuse in your application.
- Include details and descriptions that paint a picture in the mind's eye of your reader.
- Review the "Good Writing Principles" section in this chapter (page 72) as you edit your answers.
- Have a proofreader review your final draft.
- Enlist a kind and critical reader as you hone the final draft of your application.

6 • stand out from the crowd

Step into the funder's shoes.
This helps you decipher
what's most important
to them.

The competition for artist grants is stiff. The statistics can be sobering, if not depressing. For example, Creative Capital receives two thousand to three thousand applications for forty-five grants. But before you decide that grants aren't worth your time, dig into the numbers. Although an exact figure is impossible to calculate, several grant officers told me that some applications are disqualified before they are even read. The applicant either didn't follow directions or wasn't an appropriate match for the grant—something the grant writer should have figured out before submitting the application. So, you're really not competing with everyone who drops an application into a mailbox. You're only in competition with the other A-plus efforts—which is a much smaller pool.

Using Creative Capital as an example, out of the more than two thousand submissions they receive, six hundred are asked to submit a more detailed application. So the numbers look much better after the first cut. From those six hundred applications, two hundred and fifty are reviewed by a panel that chooses forty-five grant awardees. Yes, the competition is extremely stiff at these last stages. But it's not as if you're in competition with the three thousand who applied in the beginning.

At the local level, the numbers are a little more heartening. For its 2011 fellowships, the South Carolina Arts Commission received 119 applications for four artist awards. In 2010, the commission launched a new grant to support "artist-driven, arts-based business ventures that will provide career satisfaction and sustainability for South Carolina artists." About forty artists considered applying, fourteen submitted "intents to apply," seven were invited to submit applications, six submitted applications, and two artists were funded.

Write with a sense of passion. You are trying to electrify an audience. The reviewers are reading three thousand applications. If you want to end up being one of the forty-five at the end, you've got to pull people in.

· KEMI ILESANMI, DIRECTOR OF GRANTS AND SERVICES, CREATIVE CAPITAL ·

So even if the numbers appear daunting, if you and your project are a good match for the grant, apply anyway. To ensure that your application rises to the top of the heap and doesn't get cut in the first or second pass, evaluate your proposal from the funder's viewpoint.

See Through Their Eyes

In my grant-writing workshops, we play a game where I give participants an imaginary $5,000 to bequeath to an artist. I then invite an artist to describe a project she wants to get funded. After the participants listen to her presentation, I ask, "Are you ready to write a check? If not, what more do you need to know about this project to convince you to support this artist?"

Moments ago, these artists walked into the workshop thinking they knew nothing about grant writing. Then, by posing as donors, they transformed into ruthless philanthropists full of questions. Even their body language changed; slouchers sat up straight and leaned in. Hands shot up. Questions ensued: How will the money be spent? How will the project be carried out? Who is on your team? What is the timeline? Where is the venue? How is this project meeting a need? Why are you the best person for the job? and so on. These unsure artists become shrewd patrons, just by shifting their perspective.

Play this game as you edit your grant application. Step into the funder's shoes. By now in your process, you should know what matters to them. If you don't, continue your research. Talk to others who've been funded by them. See what other projects they've funded. This game forces you to scrutinize your project from every angle. How could it better fit the mission of the granting organization? What is still unresolved? Would you fund this project? Why or why not? You may even identify some strengths of your proposal that you hadn't noticed.

This game helps you ask the toughest questions. Don't be afraid of such a rigorous process—it's the process the funder will use. And it lets you know if your project is ready. Funders want clarity, specifics, and accountability. If your application doesn't pass your own scrutiny, take the time to flesh it out or propose a different project that's more fully realized.

Another way to stand in the funder's shoes is to think about how you're a philanthropist right now. How do you decide which causes to support? When a solicitation letter arrives in the mail, what prompts you to give sometimes and not others? What makes you give your own money away?

I donate to the Humane Society and to causes that help women in developing countries start their own businesses. I support Oregon Public Broadcasting, and I've written checks to local theater groups, environmental causes, and political campaigns. What ties all these things together? I believe in these organizations and care about their missions; I want to help. I'm excited about dogs finding good homes, impoverished women earning money through entrepreneurship, and the local theater company staging another year of performance.

If you think about the causes you donate to, you'll see that they reflect your values and show what you believe in, and care about. Your grant application must persuade another person to believe in and care about your project. Make your enthusiasm contagious. Show that what you do is exciting. That's what it takes to convince somebody to write you a check. It's what happens to you when you donate, and it's what needs to happen to your potential donors.

Skeptics might say, "It's easier to get people to care about homeless dogs and public radio. Those projects are necessary." So, ask yourself: How is your project necessary? How is it needed? How will it expand someone else's experience of the world? How will it start a revolution?

One of the best ways to practice seeing through the grantor's eyes is to serve on a panel that awards funding. If you're invited, jump at the chance, and if not, call a local arts organization and volunteer. The job is unpaid and requires long hours, but it's the quickest route to learning how to write winning proposals.

"Reviewing applications on a grant panel changed my entire understanding of the granting process," said Jeffrey Selin, writer and cofounder of the Writers' Dojo in Portland, Oregon. He noticed that most unsuccessful applicants "breezed by key points and assumed that we knew

Your application must persuade another person to believe in and care about your project. Make your enthusiasm contagious.

what they were thinking," he said after serving on a panel to award literary grants. Successful applicants "had the white-hot desire that 'this project needs to happen,' Those were the applications that impressed us, but it wasn't expressed in an egoistic or pompous way," he added. They explained their projects with detail and enthusiasm, and showed the panel what made their projects both relevant and exciting.

Study the Review Criteria

Many granting organizations provide a list of the criteria they will use to judge your application. This list isn't as exciting as the answers to a final exam, but it does explain how your application will be scored and what's most and least important to the funder. Read these criteria many times throughout your writing process.

For example, if you apply for a Community Arts and Culture Grant from the Hillsboro Arts and Culture Council, the application packet includes one page of Review Criteria detailing how your application will be judged. You will receive up to fifty points on the overall merit of your proposal, up to thirty points on how your project will impact the community, up to fifteen points for your marketing plan, and up to five points for your evaluation plan for a total potential score of one hundred points. The criteria also explain exactly how each category will be judged.

You should use this criteria list to scrutinize your proposal throughout the writing process. It's the most helpful cheat sheet you'll find.

Imagine Your Reader

Author and visual artist Mira Bartók, who dispenses grant-writing advice monthly to thousands of readers on her blog, Mira's List, has noticed that people "who might write beautiful letters sit down to write a grant and suddenly they sound overly academic and stiff." To help loosen up,

she suggests grant writers "Imagine the person across the table from you. Then tell him a story."

If you write your grant to the brick wall of an institution, it's easy to sound generic and impersonal. Instead, visualize the person reading your application as someone waiting to fall in love with a project that matters. Your voice is more likely to be authentic and passionate.

Tell a Story

Well-written proposals tell a story, with a beginning, a middle, and an end. The beginning is what you've done as an artist previously, the middle is where you are now, and the end is where you want to take your work next. "You want to write about how your new project is a movement forward," said Bret

● ○ ○

Visualize the person reading your application as someone waiting to fall in love with a project that matters.

Fetzer, who received funding from Washington's Artist Trust to write six new American fairy tales. He told this story in his winning grant application:

> I've been writing original fairy tales for over 20 years. ... These stories were set in the traditional fairy tale milieus of European forests, Arabian deserts, and Chinese mountainsides. About a year and a half ago, I decided to pursue a different flavor—to write a distinctly American fairy tale, using an abstracted setting (half Dust Bowl and half Appalachia) and an iconography (coal mines, Sunday School, state lines, capitalism) evocative of the 1930s combined with the robust storylines and broad characters of fairy tales. The resulting story—The Devil Factory, included as my work sample—was extremely satisfying and has

proven popular with audiences. And while all my fairy tales draw upon the feelings and perspectives of childhood, this story gets a particular grist from my experiences growing up in Texas and Kentucky.

I propose to write six more American fairy tales, and I am applying for this grant to help me set aside time to write. Storytelling and small-press publications do not pay my rent or put food on my table. I would like to be able to turn down some of the non-creative freelance writing work I do so as to devote my writing time to these stories. I will also perform them as a story suite this fall, for which I would rent a theater and do publicity.

In his application, Fetzer wrote about the work he'd been doing for twenty years (the beginning), then referenced a successful example of a new kind of fairy tale he'd just finished and that took his work in a new direction (the middle). And then, building on this recent success, he explained how he wanted to write six new stories in this new and exciting form (the end).

Convey a Confident Attitude

Although you'll never actually write "My project will happen with or without this grant" on your application, foster this attitude as you write and edit your proposal. Nobody, least of all funders, likes a needy person who can't do anything on his own.

Back your own project with everything you've got. Show the funder that you care more about your project than about their money. Your own belief in your project makes it enticing. Demonstrate how resourceful you are and how much you're sticking your own neck out. When one avenue was blocked, how did you find an alternate route?

Writing a grant is telling a story. It should have a plot ("This is where I am now, and this is where I want to go"), a protagonist (me—and since the panelists don't know me, I have to create a memorable character), stakes ("This is why you should care") and a strong theme ("This is the significance it will have in the world").

· TERRY WOLVERTON, AUTHOR ·

Reflect this attitude in the language you use throughout your proposal and in your budget. For example, as suggested in the "Good Writing Principles" section in chapter 5 (page 72), avoid conditional verbs (like "could" and "would") in favor of the present or future tense (like "is" and "will") and see how much more determined you sound.

Play Devil's Advocate

As you scrutinize your grant application pay attention to any nagging feelings you have about what the funder might object to. Rather than shove your feeling aside, bring your concern into the light. This is *the* time to be a harsh critic of your project—not to kibosh your idea but to make sure that you've thought through every possible objection.

I once applied for a professional development grant to attend an expensive writing workshop. As I finished the application I suddenly felt sick about one potential problem with my request: I had already studied with this teacher. Wouldn't the funder be more interested in funding a new experience? So, I asked myself, *Is there any advantage to studying with the same teacher twice? What benefit could I highlight? Should I just scrap the whole proposal right now?*

Then it hit me. One benefit of having studied with this teacher in the past was that I already knew she was a great instructor. I had learned much from her and was primed to learn even more. There wouldn't be a breaking in period. I knew the quality of what I would receive because I'd already experienced it. Rather than try to hide the fact I'd already studied with her, I highlighted this additional benefit.

Flush out any possible weaknesses in your proposal and ask yourself, *Is there any way this is a benefit?* You may be surprised by what you discover. Or, you may unearth a true weakness that you can now address.

Be Realistic

Novice grant writers often make promises or set goals in their applications that they couldn't possibly achieve. No project is going to bring world peace. The smaller, more focused your goal, the better. Funders want to see goals that are achievable and realistic. Your goal should line up with what you've already achieved. Is this project too big a stretch for you? If it is, then maybe you can collaborate with someone who has complementary skills so that the goal will be achievable.

For now, the only task left is for you to finesse the most important elements of your proposal: your artist statement and work sample. You've told the funders what you want to do; now show them what you've done and why you're the only person for the job.

your assignment

In one paragraph, write the story of your project. Where did you start? Where are you now? Where are you going? What happened along the way that compelled you to take this path and not another? Whom did you meet? What influenced you? Then, write a second version and exaggerate the details or tell it in a more dramatic way than it may have

really happened. When you're done, incorporate whichever parts of the exaggerated version still ring true into your grant proposal.

gigi's cheat sheet

- Don't let thoughts of competitors depress you; let them inspire you.
- When in doubt, ask yourself: *What would convince me to donate to my project?*
- Study the criteria that the panel will use to evaluate your proposal as you work, so you can strengthen the areas that they will find most important.
- Cut all conditional verbs; write about your project as if it already exists.
- Write with a specific person in mind so that your proposal sounds personal, not stilted.

7 • craft your artist statement, bio, and résumé

Your artist statement already
exists even if you haven't
written it. It's left tracks in
your paintings, journals,
dances, melodies. It's written
all over you.

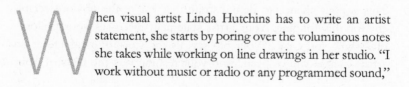

hen visual artist Linda Hutchins has to write an artist statement, she starts by poring over the voluminous notes she takes while working on line drawings in her studio. "I work without music or radio or any programmed sound,"

said Hutchins from her sunny studio with a view of the lush verdant mound of Forest Park in Portland, Oregon. "I want to listen to what comes up into my head. A lot of the times it's a voice that's trying to explain what I'm doing."

It's so funny. You think, *I'm going to be an artist so I don't have to write.* There's probably more writing than anything. But the writing helps you define your ideas. There's a clarity that comes when you have to verbalize them. Then that gives you the ammunition to go back and make the work even if you don't get the funding. Now you have this document that describes in detail what you'd like to do.

· MARK R. SMITH, VISUAL ARTIST ·

For Hutchins, this voice anticipates the questions people ask about her work: *Why do you rub silver spoons on paper to create the marks of your drawings? Can't you get a computer to do that?* Her answers end up in her artist statement. (See Hutchins's statement on page 98.) They are her self-defense, she says, because her process is anything but random.

Many applications for grants and residencies will request an artist statement, bio, résumé, or some combination of these documents. This is your chance to demonstrate that you're the obvious recipient for this funding. Your artist statement discusses your philosophy—why you create. Your bio reveals the story of your life as an artist—where you've been. And your résumé lists the facts of your

career—the marks you've made along the way. Of all of these, the artist statement is the most challenging to write because to philoso- phize about why you create requires a lot of pondering, considering, and questioning.

The benefit of all this deep thinking, however, is that a honed statement gives funders a way to understand and become enthused about your work. A good artist statement is also a manifesto for you, the artist. It's your marching orders and your reason for being. Writing, editing, and revisiting your artist statement reminds you where you've been and where you're headed. Let this manifesto keep you true to your own aspirations and creative vision.

Write Your Artist Statement

An artist statement reveals your philosophy, why you do what you do—your themes, your processes, your obsessions, and all the other details your audience needs to know. It's what viewers read in tandem with experiencing your work, whether that work is hanging in a gallery or submitted in a grant application.

A statement can be as short as a few sentences or as long as one page. All artists (including writers) need one. You'll use your artist statement many times during your career, for instance, with

- Grant applications
- Residency applications
- Teaching applications
- Gallery shows
- Portfolio
- Website
- Graduate school application
- Press packets
- Catalogs
- Theater programs

○○○ ○ ○●○○

A good critic is a better writer than most artists. But often an artist, if they think about their work, is better than a fast reviewer, a fast critic, or a fast curator just quickly trying to get something at the last minute for a press release.

· DREAD SCOTT, VISUAL ARTIST ·

The most important use of an artist statement, however, is a private one: It's what you, the artist, express and understand about why you do what you do.

Your artist statement helps you decide which project to pursue next. It'll remind you what is most important to you. It's also a record of your growth as an artist. The statement you wrote at twenty-five will be very different from the one you write at fifty-five. Your statements help you track and appreciate the trajectory of your career. As you develop your career, you will absolutely need one.

Writing your statement may make you irritable; most artists won't write a statement until they absolutely have to. Some don't like to analyze what they do. While you're working, you may not have words to describe your pursuit. You may even feel that analyzing it destroys some magic. Fortunately, first you create the work and then you look for the words to describe it. If you don't, find other people—your audience and your friends (artists and nonartists)—to help you find the language.

The most useful aspect of writing an artist statement is the actual process of writing one. It grounds you. It forces you to fess up, to admit what it is you're after. Expressing your creative goals gives you direction and keeps up your momentum. Writing an artist statement helps you find your own true north.

The artist statement you write for a grant application can be organized by theme, by chronology, or some other way. It might tell a story: This is where I began, I was influenced by that, then I brought in this element, and this is where I'm taking the work next. The statement can place your proposed work in context of the arc of your career and take the reader on a journey that has a past, present, and a future.

There is no one recipe for writing an artist statement. However, because an artist statement will be read by other people, start by asking, *Who is my audience? What am I using this particular statement for?* Like every other aspect of your grant application, your artist statement must be customized for each grant because each funder will be most interested in a different aspect of you and your work.

If your artist statement will appear alongside your work, your audience wants a look inside your process. They want to know what makes you tick. The more abstract your work is, the more the audience needs you as a guide. "People are curious how your brain works," said Hutchins. "I try and tell them. I'm curious how my brain works, too, so I like to write about it."

For some audience members, a statement is a window to understanding the art. Some people don't know how to talk about art, and a statement teaches them how. It's a visual, literary, or aural aid that helps them expand their world. With the statement, your audience may find more of an emotional connection to the work. Now they know the story behind it.

Not every artist wants the viewer to know the story behind the work. That's fine. If that's the case for you, your artist statement can be a series of questions—maybe questions you were asking when you made the work that never got answered or questions you are always asking.

Collect artist statement from artists you admire. Many artists' websites have artist statements, so they're easy to find. Read as many statements as you can and emulate the ones that speak to you.

You'll need to have several different statements for different purposes to emphasize specific aspects of your work. Think about what

you're using your statement for and you'll know what to include and delete. When I was applying for a residency that would enable me to perfect my skills in performing my work on the radio, I emphasized the aural, spoken aspect of my writing. If I had been applying for a literary grant, I wouldn't have mentioned this aspect at all.

Start writing your statement by answering any of the questions in the assignment at the end of the chapter, or have a colleague interview you using some of those questions. Write down your words and phrases verbatim. You may need this interview before you put pen to paper. To generate even more answers, use these questions to interview your audience. They can't talk about your internal process, of course, but they can tell you what they experience in your work. Their comments may resonate with your intentions or be the kick-start you need.

Hutchins advises artists who find it hard to talk about their work to start by asking, *Why is my work hard to talk about?* Your answer may be the doorway into your own words.

Even if a grant application doesn't specifically ask for an artist statement, it can be a handy reference as you compose your answers, pulling pieces from it as you describe your goals, aspirations, and plans for your next work. Your artist statement will always be a work in progress. Print it in large type and tack it to your workspace wall. Read it regularly and add notes, cross out what's no longer true. It will evolve over the rest of your life, so don't worry if it never feels done.

In the examples of artist statements on pages 95–98, notice the topics artists chose to include: the art-making process, historical context, philosophy, autobiography, intended impact, and recurring themes. Some even reference past work as examples of how they manifest their philosophy.

Dos

- Write in simple sentences.
- Write about yourself in the first person—that is, use "I" rather than "she" or "he."
- Choose descriptive language that paints a picture in the mind of the reader.

- Keep your audience in mind.
- Use twelve-point type and paragraph b easy to read and navigate.
- Be specific to yourself and to your work.
- Reflect the tone of your work in your statement—for example, if your work is humorous, your statement can be funny.
- Reveal your medium, especially if there's potential for confusion; however, don't describe what is obvious to the viewer.

Don'ts

- Avoid jargon, technical terms, abbreviations, and acronyms.
- Don't use convoluted language.
- Avoid clichés.
- Refrain from philosophical generalizations.
- Don't tell the audience how they'll feel in response to your work. Instead, describe your intentions.
- Don't mention your childhood unless your work is autobiographical. Even then, be brief.

Sample Artist Statements

Each artist statement is as unique as the artist who writes it. I've included two examples to show you the range. As you find and study others, you'll see a variety of tone and content.

VISUAL ARTIST STATEMENT · Linda Hutchins begins with the title of her work and the dictionary definition of those words. She continues with a brief description of her art-making process, the effect she creates, and the historical context. She concludes with a touching explanation of her personal connection to her tools and the meaning behind the work.

LINEAL SILVER

LINEAL:

1. relating to a line or lines; linear

2. in a direct line of ancestry or descent

3. hereditary

SILVER:

4. a soft metallic element capable of a high degree of polish

5. articles of domestic use, such as tableware, made of or plated with silver

6. anything having the luster or appearance of silver; a neutral gray of medium brilliance

I draw these lines directly on the walls with a silver spoon. The spoon leaves a trace of actual silver as I walk from one end of the wall to the other. Accidental nuances create undulations that ripple like water, clouds or hair. Line records the present moment through the pressure and pace of my movement.

Artists have made drawings in "silverpoint" for centuries, using a rounded piece of silver wire rather than a spoon. While silver won't make a mark on plain paper, it will leave a delicate line on paper or board that has been coated with gesso. Ordinary wall paint is similar to gesso and creates a surface that is surprisingly satisfactory for silverpoint—and silver spoon—drawing.

The spoon I use belonged to my grandmother or to a close family friend. It deposits a vestige of the past as well as the present. In our time, silverware is acquired through inheritance and valued as a reminder of previous generations.

We use it on special occasions among family and friends. Drawing with silverware links the physical line with the metaphorical lineage of ancestry, and the repetition of the drawn lines with the repetition of generations.

ACTOR/PLAYWRIGHT ARTIST STATEMENT · Aaron Landsman first describes exactly what his work is, then goes on to explain the unique venues for his plays. He continues with a description of what he's striving for in the work, including the varied theatrical elements he uses. Notice Landsman's powerful verbs: witnessed, burnish, embedded, bounce, and so on. His phrases are fresh and evocative, much like his work.

I make live performances that mix scenes, monologues, dance, installation, and the occasional cheap pratfall. I come at playwriting three-dimensionally; the text is a vehicle for embodiment and lives best when breathed, shaken, stirred, and witnessed. Many of my pieces are staged in apartments, offices, and other familiar locations, while others utilize established performance venues. Having created performances in a range of theatrical styles—from multimedia ensemble collage works, to plays strongly anchored in narrative and character—I am now working to make theater that draws from the best of these methods.

With each script, I try to burnish everyday intimacies and transgressions until they take on aspects of the epic, and to reveal deeper tensions embedded in unassuming situations. The narrative force accumulates through a structure and acting style that may seem offhand one moment, driven the next. Monologues, fourth wall scenes, subtle asides to viewers, and the occasional cheap pratfall all build on and bounce off each other until the audience is caught up in the same maelstrom as the characters themselves. I want immediacy and hindsight to

exist in the same performative space. I write about nostalgia a lot, and the patina we place on the past from within the present seems an ideal predicament for theater to address.

Working site-specifically has been immensely rewarding for me. It has helped me try and understand some essential things about theater without being limited by the constraints that often hamper emerging artists (tight tech schedules, intense financial pressure, an assumed relationship among audience, text, and performer). I am beginning to envision a kind of theater-making that brings lessons I've learned from working outside the theater back into the space itself.

Write Your Bio

If your artist statement is your philosophy, your bio is the factual narrative of you. Written in sentences—not a list, like a résumé—it's the story of who you are, what you make, where you were educated, and where your work has been seen or experienced. A bio can be as short as a paragraph and as long as a page or two.

Your bio also can include personal details including your birthplace, where you were raised, and where you reside now. You can include funny or interesting details about yourself, but avoid being cutesy. Every detail you reveal in your bio should have some relationship to you as an artist or to your artwork and the project you're proposing.

Unlike an artist statement, a bio should be written in the third person—using "she" and "he," not "I"—so that it sounds like somebody else is writing about you. Writing about yourself in the third person can feel strange, but sometimes this exercise alone—writing about yourself from the outside looking in—can provide the perspective you need to stand back and discuss your work as though you didn't make it.

Sometimes an application will give you the choice to submit a bio or a résumé. If you're still an "emerging artist" and your résumé is skimpy, submit a bio instead.

Performance Artist's Bio

Linda Austin includes the facts of her work—where she's performed, the benefits of her new studio location, her education, and her funding history—in her long bio.

> With a background originally in theatre, Linda Austin began making performance and dance in 1983, when her first piece was presented at the Danspace Project at St. Mark's Church. As an active participant in the downtown New York dance and performance community until 1998, Austin presented work at Performance Space 122, the Danspace Project, the Kitchen, and Movement Research at Judson Church. From 1992 to 1994, she lived and made work in Mexico, returning to Mexico City in 1998 for a two-month residency sponsored by Movement Research and funded by the U.S./Mexico Culture Fund.
>
> In 1998, needing a more expansive and stable environment for the creation of work, Austin moved to Portland, Oregon, bought a small church that became her studio and, with lighting designer Jeff Forbes, founded the performing arts nonprofit Performance Works NorthWest. PWNW serves as the parent organization for Linda Austin Dance as well as the catalyst for other projects, such as a 2002 residency and commissioning project with New York-based choreographer Sally Silvers.
>
> In the Northwest, Austin has performed in Northwest New Works at On the Boards and as part of Portland Institute for Contemporary Art's TBA Festival; at Velocity (Seattle), Conduit, the Echo Theatre; and at her home studio, Performance Works NorthWest.
>
> Supporters of Austin's work have included the Oregon Arts Commission, the Paul G. Allen Family Foundation, the New York Foundation for the Arts, Movement Research, the U.S./Mexico Cultural Fund, Oregon's Regional Arts and Culture Council, and the Djerassi Resident Artists Program.

Her writing has appeared in *The Movement Research Performance Journal, Tierra Adentro* (Mexico), the literary journal *FO A RM*, and a 2003 collection from MIT Press, *Women, Art and Technology*.

Musician/Sound Artist's Bio

Ethan Rose presents a hybrid artist statement and bio. He mentions his influences, the types of projects he's created, the instruments he uses—a unique aspect of his work—and what he hopes his audience will experience.

> Ethan Rose's work reflects his interests in old technologies, new sounds, and the restless exploration of musical form. Over the past ten years, he has released recordings, scored films, performed internationally, created sound installations, and worked with a variety of collaborators. Drawing from his interests in musique concrete, chance operations, and American minimalism, Ethan creates shifting sound environments that merge the old with the new.
>
> His music is electronic in nature but maintains an organic quality because of his exclusive use of acoustic sound sources. Much of his recent work has centered around instruments from eras long past, including music boxes, player pianos, and carillons. However, he is interested in pulling new sounds and ideas out of these antiquated devices rather than treating them with a sense of preservation. By bringing a carefully detailed sense of arrangement to his music, Ethan's pieces transport the close listener to a warm and unusual place.

Author's Bio

In her bio, author Donna Matrazzo includes sensory details about the places she's lived. Because she writes about the environment, this emphasis on the natural world of her surroundings makes perfect sense.

There were no woods on Wood Street, in Braddock, Pennsylvania, where I grew up. Nor any connection to the natural world. Just one block of sooty homes, choked between the railroad tracks and the steel mill. Houses were so close together that if we shook the dust mop too far out the hallway window, it was in Mary Mihalko's living room.

Braddock was the home of the first Carnegie Free Library, and I toted home armfuls of books whose pages took me on adventures I was determined to have when I grew up.

We studious sorts were encouraged by our high school headmaster to aim for college, assured that we would find scholarships and loans to see us through. It worked, and a degree in journalism from Duquesne University gave me solid grounding for a life beyond anything I'd imagined.

Now I live on Sauvie Island, at the confluence of the Columbia and Willamette Rivers, on the outskirts of Portland, Oregon. My house is nestled between an acre and a half of my own woods, and a seventy-five-acre state natural area across the little country road. Trilliums bloom by the hundreds in spring, and herons, hawks, bald eagles, tundra swans, and sandhill cranes fly overhead.

From this outpost I have travelled afar: Bali, China, Tibet, a summer bicycling across Europe, three week-long bike trips around Oregon, kayaking in Glacier Bay and the Fiji Islands, rafting, cross-country skiing, tromping, and camping through many a U.S. and Canadian wilderness.

I'm a founder of the Oregon Ocean Paddling Society and the Sauvie Island Conservancy, trained in Wilderness First Aid, a certified Schoolyard Wildlife Steward, and on the advisory board for the Columbia River Water Trail, and I have worked part time for Audubon and as a sea kayak guide.

Write Your Résumé

If your bio is your story, then your résumé or curriculum vitae (CV) is your fact sheet. It's the details in black and white.

Include the following information in your résumé:

- Name and contact info
- Work history (if relevant)
- Education
- Exhibitions (solo and group)
- Residencies
- Awards, grants, and fellowships
- Press coverage
- Collections
- Published works, including name of publication and date
- Any other facts associated with your art, including dates, locations, and other relevant details.

Customize your résumé for each application you submit. Every item on it should relate to that specific grant and that specific project. For example, when I'm applying for a literary grant, I don't include my teaching experience; the funder is not interested in me as a teacher but as a literary artist.

List your education only if it's relevant. For example, a visual artist with a bachelor of science degree in mechanical engineering would likely list the degree, especially if her work relates—however tangentially—to engineering. I usually don't list my certificate in advanced French from a prestigious Paris institution, because it's irrelevant to my writing now. However, if I were applying for a residency in France, I would list it. So, if your experience relates to the work that you're describing on your application, list it; if not, omit.

The challenge for experienced artists is keeping the résumé to two pages. Read the application guidelines and find out if there is a page limit, and if so, stick to it. Leave in the accomplishments that are most

recent, most impressive, and most relevant to the funder's interests and the project you're proposing. Be sure to proofread (or have someone else proofread) your résumé to eliminate typos, and be consistent in both the form and content of your list of achievements.

If you're unsure how your résumé should look or what it should include, look at what other artists have done. Many artists post their résumés online, so look up some colleagues' websites. If a granting organization gives you access to past successful applications, study the résumés submitted. Or ask an artist friend who has won that grant if you can look at the résumé he used. Bhandari and Melber's book *ART/WORK: Everything You Need to Know (and Do) as You Pursue Your Art Career*, listed in Appendix A: Where to Find Grants and Residencies, includes an excellent section on résumé writing for the visual artist.

If you're an "emerging artist" and the application gives you the choice to submit a bio or a résumé, submit a bio instead and continue to build your résumé until it's a full page long.

The most important aspect of résumé writing is to include only the information that is relevant to the grant and to your artwork. If you work as a barista and you're applying for a playwriting fellowship, don't include this job. Write your résumé to present you the artist. If you're having trouble deciding what to include, imagine that you're on the panel and ask yourself, *Does this detail support the proposal?* There's your answer.

your assignment

Buy a new notebook and a metallic magic marker. Label the cover MY MANIFESTO. Turn to the first page and answer the questions below to jumpstart writing your artist statement. If you get stuck, think about what worries or obsesses you, or what's still nagging at you after all

these years. Remember that all of your answers must relate to the project you're trying to fund.

- What does the grant-review panel need to know about my work? What's important to them?
- What process do I use in making my work? What special research am I conducting?
- How do I make my work, step-by-step?
- What's unique about my process or my result? What makes my work like no other?
- Where do I go for inspiration?
- How has making art saved my life?
- How did my earliest years or upbringing affect my art?
- What first drew me to this art form? What was I seeking? Did I find it?
- Who are my influences—mentors, trainers, or famous artists I have never met?
- What excites me most about my work?
- What obsesses, fascinates, or haunts me? What still keeps me up at night?
- What am I worried about? curious about?
- Did I choose this art form, or did it choose me? How?
- How does my work fit into the history of this type of art-making?
- What do I want my audience to feel, question, wonder, understand, or do after experiencing my work? What's my goal?
- If my work were music, what kind of music would it be, played with what kind of instruments?
- If my work could speak, what would it say it's about?

gigi's cheat sheet

- Customize your artist statement, bio, and résumé for each grant application you submit, including only the information that's relevant and supports your case.
- Use headings and paragraph breaks so the document is easy to read and navigate.
- Be consistent with all formatting.
- Draw inspiration from other artists' artist statements.
- Write your artist statement in the first person (using "I") and your bio in the third person (using "he" or "she").
- Make your statement a living document that you read and edit regularly.

8 • showcase your art with a stellar work sample

Your work sample must prove

beyond doubt that your

next project is the inevitable

outcome of all that you've

done before.

My grant-writing students often ask me, "What's the most important element of a proposal?" They want to know what matters most—the project description? the budget? the cover letter? I tell them: it all matters. If a grantor requests it, then it's important. You can't discount any aspect of a grant application. However, if I had to choose one, the most important and most often overlooked element is the work sample.

The work sample is the documentation of your past creations, and it can make or break your application. You can write the most

beautiful and compelling answers to the questions on the rest of your application, but if your work sample doesn't live up to the promise of those words or is of poor quality, your chances of landing the grant are slim. A strong work sample will stop the reviewer in his tracks. Your work sample should be of the highest quality and demonstrate that you have the skills and experience to successfully complete your proposed project.

More mundane, but equally important, is to follow the instructions for presenting your work sample. Literary artists have it easiest, because their work samples are usually text. Yet even for them, the granting organization will have specific submission guidelines. For example, if the rules say, "Submit five poems," then don't submit three or seven. However, if they say, "Submit *up to five* poems," then three or four of your best is fine. They may request eight copies, double-spaced, paper-clipped, not stapled, with your name in the top-left-hand corner. These details may sound irrational, but imagine that you were receiving hundreds of applications; you'd want to make it easy for your underpaid assistant to assemble the three-ring binders for the reviewers too. And you'd want to ensure fairness in the review process.

A strong work sample will stop the reviewer in his tracks.

Visual artists will need to submit digital files by e-mail or on a CD, also called a CD-ROM. (Review the instructions for the exact format. As technology evolves, so does format.) Performance artists may be asked for an excerpt of their work saved to a DVD. The application instructions will list specifics about the excerpt's length and format as well as the number and types of images. Follow these instructions to the letter.

When you assemble your work sample, put the strongest work first. If you're a visual artist, find out how the work will be screened during the review process. If several images will be projected at once, order the work so you control which images are viewed together. For example, I've heard that the review panel at the New York Foundation

for the Arts views a total of twelve images, four at a time. In that case, I'd put my four strongest first and make sure that each subsequent grouping contains four images that work well together.

For performing artists, playwright and actor Aaron Landsman recommends shooting the performance more than once and with more than one camera. "I know successful artists who videotape five or six nights of a three-week run. They borrow a camera or get a professional to do it, but they make sure they get really good documentation," he said. Visual artists doing installation work should document on several days and photograph both inside and outside perspectives of the installation.

Beware of technical glitches. I was shocked to hear that several grant officers have received blank CDs and DVDs. Don't give the panel an easy reason to disqualify you by not following the application guidelines. One unsuccessful applicant, a printmaker, complained that the panel should have called him regarding the blank CD or have gone to his website to view his monoprints. I also heard of one dancer who submitted an hour-long videotape and told the panel to forward to the last five minutes. This applicant should have submitted a tape containing just the relevant excerpt. It's not reasonable to expect the panel to do extra work; the applicant is responsible for making sure he has submitted a proper sample in the correct format.

Choose Your Work Sample

"I try to remember that I'm not picking the best work, necessarily, or even my favorite work. I'm looking for the most compelling image of my work," sculptor Bonnie Collura said. While she works in her studio, she often stops to photograph her work in progress. "I take so many pictures because it helps me to really see my sculpture. When I'm looking at the sculpture on the camera, I can see how it translates as an image."

Kemi Ilesanmi, director of grants and services at Creative Capital, urges artists to "choose something that draws people in right away. You don't want a lot of credits at the beginning of a DVD. Then you've wasted one whole minute. It doesn't create anticipation; it creates frustration,"

she said. "We want the artist to take us into the middle of something so that panel members are engaged in the work right away."

In addition to gripping the viewer, your work sample must relate to the project you're proposing. Sean Elwood, director of artist programs at Creative Capital, understands that this may be difficult for applicants because their proposed projects don't exist yet. However, the sample must relate to what you're planning in some way. "If you're normally a painter but now you're doing a video piece or paintings that will incorporate video, show us some indication that this is not the first time you've worked with video," he said. "We want to see ... that you have the chops, that you can accomplish this. If you're going to do something new and exciting in your artwork and then you just show us stuff that has nothing to do with it, in terms of content and form, it's harder for us to judge," he added.

Document It

Submit a work sample description to accompany your work sample. Pertinent information to list here includes your name, contact info, and facts about each sample (title, medium, size, publication, and date, if applicable).

●○● ◯ ●○○

You have to make the work sample very relevant to what you're proposing and very easy for the panelist to navigate. Don't make them do any extra work to get them to what you want them to see.

· KEN MAY, EXECUTIVE DIRECTOR, SOUTH CAROLINA ARTS COMMISSION ·

If the guidelines allow you to include a brief description, use this opportunity to orient the panelists. Remember that they have never seen your work and will need some guidance to understand what they're looking at. For example, if your drawings are delicate and hard to decipher in a photograph, mention this aspect in the description. Putting the work in context will encourage panel members to look more closely and better appreciate your work.

Spend as much as you can afford on the highest-quality documentation of your work. The work sample that you submit is the only way the panelists will experience your work. If it doesn't do a fantastic job of showing off what you do, then the panelists probably won't see your work in all its glory, appreciate it, or fund it.

Photographing Your Work: Advice from a Pro

How do you ensure you capture the best images? If you need to hire a professional, where do you start? For the best advice on photographing two- and three-dimensional artwork, I turned to professional photographer Grace Weston.

Weston has been photographing artwork for twenty years from her studio in Portland, Oregon. She understands that her images are often the first and only time a panel will see the artist's work. She strives to create a photograph that's as close to the real thing as possible. Although Weston advises hiring a professional, read on for tips on documenting your own work.

GIGI: *What are your tips for how to hire a professional photographer?*

WESTON: Photographing artwork is a specialty, with considerations and sensibilities that differ from those needed for wedding, portrait, or landscape photography, for example.

Ideally, you want to hire a photographer who has experience shooting artwork, (both two-dimensional and three-dimensional), and is familiar with how artwork is professionally presented for portfolios, calls for entry, and media publication. Ask other artists, your local arts council, or local art museum for recommendations.

It's important that the photographer have a system to provide accurate color of the artwork, which is of far less concern in other photographic specialties. Ask if you can meet in person for a free consultation, and if possible, bring a sample of your work to show the photographer its characteristics. Look at the photographer's examples of photography of artwork for artists, online or when meeting in person. Also ask for references.

GIGI: *What specific qualities should an artist be looking for?*

WESTON: Look for a photographer who exhibits professionalism, has experience shooting artwork (ask to see samples, either printed or online), and has a studio with photographic lighting equipment. To me, when hiring for any professional service, personality is important as well as a sense of mutual respect. This is a relationship that, hopefully, will continue for years, as a partnership of sorts.

The photographer is a teammate, providing you with tools (the images of your artwork) to move your career forward (through juried shows, publication, web presence, etc.), with a genuine interest in your success (by providing you with the best possible representation of your work). A photographer who answers your questions and shows a genuine interest in supporting artists can be an invaluable ally.

GIGI: *What questions should an artist ask?*

WESTON: How does the photographer charge for the work? Is it by the piece, by the hour? Is the digital file processing charged separately? If it is by the hour, is it possible to get an estimate or bid up front? If you have a set budget, let the photographer know and ask what can be provided within that budget.

Make sure to let the photographer know as much as possible about your work—the medium, size range, unusual materials or reflective elements (is it wired for hanging, framed, or under glass?). Does the photographer want you to be present for the shoot or to just drop off the work?

Does the photographer shoot the work in Camera RAW (the professionally preferred mode, as it contains the most digital information)? Will you receive images in TIFF format? What is the turnaround time? When is payment expected? What will the artist receive—a CD? [also called a CD-ROM] any kind of printout? What size will the files be? Does the photographer

● ○ ○ ◯ ● ○ ○

Photograph your work yourself only if you can really do it justice, as this is the most important tool you have to represent your work, as a professional artist, when you do not have the chance do that in person.

· GRACE WESTON, PHOTOGRAPHER ·

keep an archive of the work on file, in case some future event results in the loss of your image files?

GIGI: *What happens during a photo shoot?*

WESTON: Usually, the artist has phoned or e-mailed me beforehand and we have had a lengthy conversation about the work and what the documentation is for. At the studio, the artist and I look over each piece of artwork, and I quickly identify any questions I might have, for example, from which angle would the artist like to have a three-dimensional piece shot. I take notes, counting the pieces and recording the number of shots desired, and make sure the artist is clear on what she will be receiving and when.

I usually like to work alone, but on occasion, I might have the artist stay to help switch out the artwork (saving time on a large volume shoot) or to approve the progress on a particularly involved shoot (of an installation, for example).

I shoot in Camera RAW format and provide the artist with a CD of fully processed TIFF files (plus JPEG files for the web, if requested) and a printed index sheet of the images. A side note here: JPEGs are compressed files and should not be used as master files, because they do not hold up to repeated resizing. Your master file should always be in an uncompressed form, such as a TIFF or PSD. A professional photographer should know this. I walk my clients through the process of creating JPEGs from TIFFs for their future needs, if they need the help.

GIGI: *What if the artist doesn't like the results?*

WESTON: If you are not pleased with the photography you get (and pay nicely for), let the photographer know and be specific.

Give the photographer a chance to make it right for you. This will only improve your communication with each other and deepen the photographer's understanding of how to best represent your work in future sessions.

GIGI: *Do you have any suggestions for an artist photographing her own work?*

WESTON: Photograph your work yourself only if you can really do it justice, because these images are the most important tool you have to represent your work as a professional artist when you do not have the chance do that in person. Do not shoot your artwork leaning up against a tree in your backyard or with your friend's hands shown holding it. You may laugh; however, I have seen those exact examples submitted to a gallery owner for consideration.

Look at magazines or books that show professionally photographed artwork in your medium. Observe what kinds of backgrounds are used to set off the work. Get a book from the library on how to shoot artwork. If you use window light, fill shadows or balance the light with a white bounce card. On two-dimensional work, distribute the light as evenly as possible on the canvas. Choose the correct white balance for your light source.

Be observant. You need to really look and see what is going on in the viewfinder. Watch for reflections, highlights, shadows, edges, and tangents. Do you want textures to show? Observe how changing the angle of the light changes how the work looks. Get a tripod. It is difficult to be square to a painting or to level the camera to the ground when shooting a sculpture if the camera is hand held.

your assignment

Block out sixty minutes of uninterrupted time: Silence your cell phone, disconnect from the Internet. Open the file, closet, or storage locker where you stash past work. Read, watch, listen to the creations you've made. Note where you feel chills and where you feel most excited. Which pieces speak to the white-hot center of the next project you want to get funded? Make a pile of the work that is the most striking and the closest in tone or style to your next project idea. Contact a colleague—someone smart and generous. Make a date to have him review this pile and help you choose a work sample that will knock the panel members out of their chairs.

gigi's cheat sheet

- Give yourself ample time (three to four weeks) to choose and prepare your work sample.
- Spend as much money as you can afford on documenting your work so that your sample is the highest possible quality.
- Your work sample speaks for you at the review panel. Make it a clear and striking example that relates to your proposed project.
- If you hire a professional photographer, get a referral from a satisfied customer or interview some of the photographer's

past clients. Be clear about what you want. If you're unhappy with the results, speak up.

- If you decide to photograph your own artwork, study and emulate images you admire.
- Follow directions on the application so you submit exactly what the grantor wants. (Have I said this enough?)

9 • budget fearlessly

Your budget is the story
of your project told with
numbers.

used to hate budgets. Even the word was ugly. Squat. Clipped. No
fun whatsoever. A budget felt like a grapefruit diet, something that
had to be done if I wanted to be svelte but which left me feeling
deprived. I didn't want to record dollars in black and white; the
numbers laid bare made me nervous.

When I was growing up, if my mother wanted to buy something
expensive, like nice fabric to reupholster a couch, she bought it and
then reminded me on the ride home: "Don't tell Marvin how much this
cost." He was my stepfather and might not approve. Once, on a visit
with my real father in Manhattan, we were sipping lemonade at a café.
From under the table he pulled a wad of cash and thrust it at me. "Take
it, spending money," he said like it would evaporate if I didn't hide it
quickly. I snatched it from him and jammed it in my jeans pocket. Why
was the money a secret?

No wonder I didn't want to put numbers in black and white.
I grew up believing that money, either expenses or income, must
never be recorded in the open air for everyone to see. If you really
wanted something it was best to hide how much it cost. And never
divulge where your money was coming from.

There's got to be internal consistency between the narrative and the budget so that I'm reading the same story twice. Nothing should come up in the narrative that isn't echoed in the budget and vice versa. Budgets are the Achilles' heel of many a grant writer in the arts. But remember, there's a staff at most granting agencies whose job it is to help you.

· KEN MAY, EXECUTIVE DIRECTOR, SOUTH CAROLINA ARTS COMMISSION ·

When I grew up and started applying for grants, I was forced to make some budgets. I was shocked to discover that all my preconceptions about them proved wrong. Although creating a budget made me shaky, once I had one, I felt grounded and secure—happy even. Announcing the numbers in black and white eased my anxiety. I wasn't dealing with some amorphous amount of money but rather a concrete number I could see. And having that specific number forced me to be creative about ways to find the funds. Numbers gave me the backbone to negotiate and ask for discounts, trades, and donations.

Despite all of this positive reinforcement, I still resist making budgets. Sometimes I'm afraid to acknowledge how much my artistic projects really cost to make and how much money I need to make them. But at least now I realize that my resistance to budgets has less to do with mathematics and more to do with exposing my own desire.

Most grant applications require a budget. Your funder wants to know how you plan to spend the money.

Start making your budget early in the application process. Like the rest of your application, budgets—even small ones—take time to make. You need to consider all your expenses, find out which expenses your funder does and doesn't cover, and research how much materials and services cost so that your numbers are accurate. A well-done budget demonstrates your experience and professionalism. You'll need your budget, maybe even love your budget—ugly word and all.

Flesh Out the Numbers

Your budget comprises two lists: expenses (the money you want to spend) and income (the money you'll earn) for your proposed project. Together, these two lists tell the story of your project with numbers.

If you are applying for a small grant, your budget will be fairly simple. For example, if you propose a professional development grant to attend a workshop, then your expenses might be tuition, plane fare, and hotel. If you are applying for a project grant, your list of expenses will be longer. It might include artist fees for paying yourself and your team of collaborators, materials and supplies, equipment rental, airfare, studio rental, advertising, and so on. Your income would include any funds received from other grants, donations from individuals, in-kind donations, and your own money.

Helen Daltoso, a grants officer at the Regional Arts and Culture Council in Portland, Oregon, advises artists to make a budget even before they begin writing about the project. The exercise of making a budget helps you figure out exactly what your project will involve.

Visual artist Dread Scott used to struggle with budgets, but "Now it's kind of easy," he said. "I'm just figuring out what I need—how much film? how much hard drive? Do I need to buy a new camera or microphone? Do I need airfare? Do I need to rent a car? I compare the income section with the expenses and I might end up with a $5,000 or a $30,000 hole ... that has to be filled by a foundation or something," he said. "But the hole doesn't go away. I don't say, well, I can't see how to get the money so I'll do the project with less."

A well-done budget is specific and fully fleshed out. Because of the necessary detail, don't wait until the last minute to create one. If numbers scare you, make these lists with help from one of your team members. She can interview you about your project and write down all the possible expenses. Then, she can brainstorm with you all the ways you can earn money.

If you have been running a successful art business, budgets may be no big deal for you. However, if art as a business is a new concept for you, making a budget for this one grant application will be great practice for all the budgets you'll need to make from now on in your career.

Expenses List

To create your budget, first list all the steps it will take to complete your project. Start at the very beginning and include every baby step. Take your time, and plan to work on several drafts of this document so that you don't forget any steps. Then write down every item that you'll need to purchase—such as art supplies, printing services, travel expenses, marketing materials—and everyone you want to hire to help you create the project, such as website designers or consultants. Do not concern yourself with costs for this first draft.

The sample budget (page 124) lists many of the categories of expenses you may have on any project. Refer to it while you prepare your list of expenses to remind you of all relevant expenses for your proposed project.

RESEARCH COSTS · When your list of expenses is complete, write estimated costs next to each item. Some costs you'll know off the top

of your head; others you'll have to research. How much is round-trip airfare to Iceland these days? What is the cost of printing 1,000 post-cards? What is a graphic designer's hourly rate? How much does canvas go for?

Depending on the detail of your budget, this step could take several hours and many drafts to complete. Most of the information can be found on the Internet or from your suppliers. You don't need the numbers to be accurate to the penny.

ESTIMATE LABOR COSTS · You may need to hire assistants, collaborators, web designers, photographers. List their fees at the going rate, and estimate their total fees on the basis of the numbers of hours and the hourly rates.

Daltoso urges artists to be detailed with their budgets so she can understand the design and planning of the project. In a budget, it's almost impossible to provide too much detail. "If there's a line item for artistic fees and somebody tells me the artist fees for two people are $1,000, well, I can extrapolate that that's probably $500 per person. But I'd much rather know that one of the people is the director and the other person is a lead actor and that the director is going to get $600 and so on." The details in your budget demonstrate how thoroughly you've planned every aspect of your project.

YOUR OWN TIME · Most artists are stumped when it comes to estimating the cost of their own time because many feel like they're never paid or paid very little. However, grantors expect artists to be paid for their time, and it looks unprofessional if you're not planning to pay yourself and your artistic collaborators. You may decide later to donate your time and list this donation in the budget under in-kind services. For now, estimate your time and your creative fee.

How do you estimate your time? First, calculate about how much time your project will require. To do this, walk through the steps of producing your project and write down the number of hours or days it will

Sample Budget

Expenses	Quantity	Rate	Total ($)
PERSONNEL			
Artist fees: director, actor, choreographer	3 people	$1,500/each	4,500
Assistant fees: administrative assistant	20 days	$100/day	2,000
Professional fees: designer			400
Tech design fees: lighting			1,000
Total Personnel			7,900

Note: Designer fee is for Promotional Materials.

WORKSPACE			
WORKSPACE			
Rent for rehearsal	5 days	$50/day	250
Rent for performance	2 days	$125/day	250
Connectivity (phone and Internet)			100
Utilities			100
Other: liability insurance			275
Total Workspace			975

MATERIALS AND SUPPLIES			
MATERIALS AND SUPPLIES			
Office supplies			100
Project supplies: stage set			650
Project supplies: costumes			550
Utilities: phone, fax, and Internet			750
Documentation: videographer			600
Equipment: sound board rental			1,040
Equipment: video rental			440
Printing: promotional materials	1,400		600
Postage: postcard stamps	1,000	$0.28/stamp	280
Marketing/advertising	2 ads	$250/ad	500
Other: poster hanging			50
Total Materials and Supplies			5,120

Note: Promotional materials include 1,000 postcards, 200 posters, and 200 programs.

TRAVEL			
TRAVEL			
Transportation: airfare (director)			$250
Lodging: 5 days x $100 (director)			500
Food			

Incidentals
Other
Total Travel 750

Total Expenses $14,745

Income	Quantity	Unit Cost ($)	Total ($)
EARNED			
Classes/Workshops	1	250	250
Merchandise sales: CDs	100	10	1,000
Ticket sales	200	12	2,400
Concessions			250
Ad sales: in program	4	50	200
CONTRIBUTED			
Individual donors: confirmed	10	100	1,000
Fundraisers: house party pending			750
Corporate sponsors			
Grants: confirmed—Abc Foundation			500
Grants: projected—Xyz Council			500
Applicant contribution			250
Total Earned and Contributed Income			**$7,100**

Note: E-mail solicitation letter sent to mailing list. We have already received $1,000 from this mailing.

In-Kind Donations	Confirmed?	Value ($)
Artist fees	Yes	1,500
Professional fee: designer	Yes	200
Assistant fees		
Materials/Supplies: office supplies	Yes	100
Workspace rental		
Equipment rental: video equipment	Yes	200
Printing	Yes	400
Marketing		
Design		
Other: airfare	Yes	250
Total In-Kind Donations		**$2,650**

Note: Choreographer is donating her artist fee, designer is donating half her time. Office Supply Central has agreed to donate $100 worth of office supplies. Joe's Video confirmed a $200 discount, and Patricia's Printing confirmed a $400 discount on printing. The director will donate airfare.

Total Project Expenses	$14,745
Total Income + Total In-Kind	$9,750
Requested Grant Amount	**$4,995**

take you to complete each step. Then, figure out an hourly or daily wage based on the going rate for what you do. Ask other artists what they charge or what they have listed as a rate on successful grant applications. You can also calculate your fee as a percentage of the total cost of the project—usually 10%–25%, depending on the size of the budget.

You can ask the funder if they have guidelines for figuring your artist fee. If the funder is used to working with artists, they'll know that coming up with an artist's fee is often a conundrum and will advise you on how other successful applicants have figured out the cost of their time.

Income List

If you've ever made a household budget for yourself, you know that one of the key elements of any budget is income—how much money you earn, perhaps in a few different ways. This number helps you decide whether you'll be eating rice and beans or Kobe steaks and Portobello mushrooms.

Make a list of all the possible ways you can earn money for your project. Think big. With your team, brainstorm every possible avenue for generating income. Consult chapter 11 for even more fundraising ideas. Your income list might include money that you'll raise from individual donors at events or through a direct mail campaign, merchandise that you will sell at your event, and some of your own money. Your income list should also include grants you've received or intend to apply for.

Generating your income list will require some research and estimation. For example, if you plan to sell tickets to your event, you first will need to determine a ticket price. You may research what similar events charge or base it on what you charged last time for a similar event. Next, estimate attendance—and always underestimate. If you've put on this type of event before, then you'll know how many people showed up last time, which will help you estimate how many people will show up next time. Increase this number only if you plan on doing more marketing this time.

Make your estimates conservative. If you're an emerging artist who's still building an audience, it will be unrealistic to expect to sell out for six weeks at Lincoln Center, for example. Overestimating attendance will make your proposal look amateurish.

Other Ways to Earn Income

○ ● ●

Consider all of the ways in which your project can earn money, including the following.

Merchandise. Will you be selling anything (CDs, books, T-shirts, and so on) at your event? If so, how much do you estimate you'll earn from these sales? If you've sold merchandise before at a similar event, then estimate how much you would sell at this future event on the basis of past sales. If you've never sold anything, be conservative with your estimate.

Individual donors. The review panel will be impressed by your grant proposal if you already have the support of other people. Throw a fund-raising party, and list the cash you receive as a donation on your income list. The more money you raise, the more competitive your proposal becomes. See chapter 11 for more ideas.

In-kind donations. In-kind donations are donations (or discounts) of goods or services that you otherwise would have to pay for. In-kind donations are almost as impressive as cash on a grant application because they show that individuals and business owners believe in your work enough to donate their time or products to help you succeed. Examples of in-kind donations include a program for your event from a printer and time to design your marketing materials from a graphic designer. The more donations you have, the more competitive your grant proposal will be, so get creative about all the items or services you could request from donors.

From each person (or company) who promises an in-kind donation, get the commitment in writing, in the form of a signed letter. You may need to submit this letter with your grant application. But even if you don't, it will show that your donor is serious about the donation and clarify the agreement for both of you.

Other grants. A project always looks more competitive if you've already raised money through another grant. List grants you've already received as "confirmed" or "committed." List grants you've applied for and are still waiting on as "pending" or "projected." You can even list grants you plan to apply for in this last category.

Add It Up

Add all the items in the expense list to arrive at total expenses; add all the items in the income list to arrive at total income. Subtract the income from your expenses. The remaining amount should equal the amount of the grant you're requesting. If this is confusing, see the sample budget (page 124).

To make the numbers work you may need to lower some of your expenses (can any materials be obtained more cheaply, or can you do without?) and earn more income (can you throw another fundraising party?). You may have to adjust these numbers (along with your plans) several times.

Guidelines for Creating a Better Budget

After you've created your income and expenses lists, the following tips will help you create a clear, clean, error-free budget to submit with your application.

EXPLAIN ALL LINE ITEMS • Label every line item completely. Relate each one to the expenses outlined in your proposal; none should be

mysterious. For example, rather than "Printing," list "Printing posters and postcards" and be sure that posters and postcards are discussed in the marketing section of your application. (Read the "Know Your Target Audience" section in chapter 4, page 61.)

Everything you mention in the application must also appear in your budget. For example, if you've mentioned mailing invitations via snail mail, your budget must reflect the costs of printing invitations and postage. If you've listed the cost of hiring a videographer in the budget, make sure that you've described elsewhere on your application what the video will be used for. Will it document the project for future reference, or is it part of the artistry of the project?

CHECK THE MATH • Your budget totals must be correct. Always have another person double-check your math. Believe it or not, a miscalculated budget can disqualify your application. Typos in the budget matter.

TELL A COHERENT STORY • The budget has to make sense within the scope of the project. For example, if you're planning a performance and estimating hundreds of attendees, your budget better list marketing expenses. It won't make sense to expect a big crowd but not spend any money on getting them there—unless you have already outlined a free, successful marketing plan in your proposal.

RECORD IN-KIND DONATIONS ON BOTH SIDES OF THE BUDGET • If you have arranged for an in-kind donation of goods or services, you must record it on both the expense and the income lists of your budget. For example, if your graphic designer is donating two hours of time at $50/hour, list "Graphic Designer 2 Hours @ $50 = $100" in the expenses and then list the same item under income.

REFLECT YOUR ATTITUDE IN THE BUDGET • The more income you can list in your budget and the better you show that you have thoroughly thought out every financial aspect of your project, the more

impressed decision makers will be. Done right, your budget can reflect the attitude that you're going to accomplish this project, no matter what. This attitude makes for winning applications.

Best case you'll have already won other grants for this project and collected cash from a fundraiser or two. Second-best, you have applied for other grants but haven't yet heard back and have several fundraisers planned with estimates of how much money you'll earn. Nobody likes to be the first one or the only one to finance a project. Contributors will be more excited if others before them have already donated. Individual donors and granting organizations like to give money to a project they know will succeed. Your attitude is what shows this.

Because chances are there won't be adequate room on the budget form to list all your fundraising plans, mention any past fundraising successes and your commitments for future fundraising somewhere else on the application. If you're unclear where this information belongs, check the guidelines or call the funder and ask.

CONFIRM ELIGIBLE EXPENSES · Make sure that all your budget items are for things that your grantor funds. For example, some grantors won't pay for food or equipment purchases. Listing ineligible expenses will show that you didn't read the criteria and could disqualify your grant application. If you're not sure if an item is eligible, read the guidelines. If you're still unclear, call the funder and ask.

ASK TO SEE EXAMPLES · Some granting organizations let you review funded grant applications, including budgets. Study the budget for a similar project that was successful. If any information is confusing, ask the funder for clarification. Most funders are happy to help you finesse your application, especially when you ask them well in advance of the deadline.

NEVER ASSUME ANYTHING · If you're unclear about what will and won't make your grant application more competitive, call and ask the

funder for guidelines. I once applied to the Oregon Arts Commission for a "career opportunity grant" to attend the Tin House Summer Writers Workshop. It's usually best to have more than one source of income on your grant application, and I wanted my application to be competitive. I didn't have time to do any fundraising so decided to donate a couple hundred bucks of my own money and list it on the income list of my budget. After I received the grant, I found out that the commission didn't require applicants to list any income and would have paid the entire cost of my workshop. My donation was unnecessary. Now I know to ask.

Note: Consult a tax accountant after you win a grant. Unfortunately, you'll have to pay a percentage to Uncle Sam because grants are considered taxable income. Fortunately, the expenses you incur can usually be deducted from your income. Hire professional help so you comply with the rules, but don't pay more than you need to.

No Fake Budgets

One mistake many artists make in creating a budget for a grant application is starting with the maximum amount of the grant and working backward. They may see a grant for $6,000 and think, *I want that money.* So, they create an expenses list that adds up to $6,000. This is a fake budget because it doesn't start organically with the project and ask, "What will it take to produce *this* project?" Instead it starts with "What can I invent to get that money?" Funders can tell whether an application is for a project that is meaningful or a project that was invented to get some money.

Monica Miller spoke with many artists in the course of her job as former director of programs at Washington's Artist Trust. Some artists who wanted grants invented projects that they thought would interest Artist Trust and make them eligible for funding, but the projects were not connected to the artists' work. "The most important tip is for

artists to stay true to their intentions and desires as artists and to reflect themselves in the application as much as possible," said Miller. Once, an artist who wanted funds to hire a babysitter proposed a project that included "public critiques" of her work because she thought involving the public would appeal to Artist Trust. Part of her budget for the project included a line item for babysitting. When Miller asked the artist if her work was based on other people's feedback, it was clear that it wasn't. This artist wasn't funded because the grant request didn't make sense; the project didn't relate to the artist's work. She didn't propose a project she really wanted to do; she proposed a project she thought would appeal to the funder.

The way to create a real budget is to actually write down the expenses needed to produce your project in the fullest possible way. (In *The Artist's Guide: How to Make a Living Doing What You Love*, Jackie Battenfield refers to this first pass as the "fairy godmother budget"— the budget you would have in a perfect world.) Then write down all the funding you think you can raise. "Then you see what's left," said Helen Daltoso, who reviews hundreds of budgets a year for professional development and project grants. "You might really need $10,000. You might only need $4,000. In order to produce the clearest, truest, cleanest budget, you have to start at that place." If it turns out that you need $10,000, then you can cut the expenses down to the essentials and build the income to get to $6,000.

When you start with your project's needs, it's inevitable that you'll produce a true budget. This realistic budget will impress decision makers because it shows them that you know what it takes to succeed. A skimpy budget may make them wary about whether you can actually complete the project.

● ○ ○

A realistic budget will impress decision makers because it shows that you know what it takes to succeed.

The Meaning of Money

O ● ●

Having money, wanting money, spending money, and especially asking for money can bring up your own beliefs, fears, and neuroses. You'll be working on your grant application, and suddenly notice unexplained irritation, anger, shame, or feelings of entitlement. Why would anyone feel so strongly about recording some numbers? How could creating a budget inspire such spirited feelings to emerge?

Most likely you're suffering the effects of doing something taboo: talking about money. Most people would rather discuss their sex lives than their personal finances. Money triggers emotions that have nothing to do with moolah. The sooner you uncover your feelings, the sooner you can sort through them and find your own clarity. Several books listed in Appendix C: Additional Resources to Support Your Career provide information on financial planning and help you sort out issues triggered by the green stuff.

your assignment

Imagine your project finished. It's opening night, or the final day of the workshop you attended. What did it take you to get to this moment? Start at the beginning and list every baby step you took to arrive at where you are now. What did each step cost? Let the vision of your project lead you through developing your budget, then fill in the costs. Let the numbers ground you in reality. The best budgets are born out of your vision for what you want and need to create next.

gigi's cheat sheet

- Don't scrimp on your first-pass list of expenses. Record the costs associated with your ideal project.
- Create you budget in tandem with writing the narrative of the application.
- Make sure that all items in your budget are mentioned in your answers on the grant application and vice versa.
- Record in-kind donations as both income and expenses.
- If working with numbers is difficult for you, enlist a team member to help you create your budget.
- Ask to see budgets from successfully funded projects that are similar to yours.
- Don't make a fake budget; create one that truly supports the project of your dreams.

10 • make friends with funders

Thanking people is one of the
most powerful ways to build
your community. This one act
will make you stand out from
the pack.

Author Ellen Urbani was at a dinner party one night in Port St. Lucie, Florida, seated next to Doug G., the husband of Ann G., who had read and loved Urbani's memoir *When I Was Elena*. Urbani had just decided to quit her day job to work on a novel with no clear plan for how she would earn money while writing full-time and raising two children as a divorced mom.

"My wife loves your book and I hear you're working on a novel," said Mr. G. before taking a puff on his cigar. Urbani had become so accustomed to talking about the novel and her plans that when Mr. G. asked

about her new project, she knew exactly what to say. "Yes, I am. It's called *Rose by Another Name*, and it's about two families sent reeling in the immediate aftermath of Hurricane Katrina and how a tragic accident reveals a deep family secret that first shatters and then reunites these mother–daughter pairs." She then elaborated on her ideas for marketing the book.

> Before I had an elevator speech, I would launch into a description of my work practice, and people would glaze over with utter confusion and change the subject. Now my elevator speech leads them to asking questions and then asking for my business card. An elevator speech plays a big role in starting a conversation.
>
> · AVIVA RAHMANI, ECOLOGICAL ARTIST ·

Urbani didn't know that she was pitching the book project to a potential donor. Yet by the end of the dinner, Mr. G. said he thought his wife might be interested in supporting work on the new novel. A few days later, Mrs. G. wrote Urbani a check for $25,000. Through their attorneys, Urbani and her patrons hammered out an agreement to make the funds a loan to be repaid from proceeds from the novel, if Urbani sells it. If she doesn't, the money will be considered a grant.

One of the reasons for Urbani's success (besides the fact that she was lucky enough to find herself sitting next to a philanthropist) was that she had a crisp, compelling "elevator speech" rehearsed and prepared. So when she and Doug G. struck up a conversation she knew exactly what to say.

Even if you don't regularly mingle with wealthy patrons, you'll need your own elevator speech to use for both impromptu meetings

and for when you call the funding organization about your current project. The idea of memorizing a prepared speech may put you off; nobody wants to sound like an automaton. But it's impossible for even the most gregarious wordsmith to be eloquent every time she opens her mouth. Most humans can be forgetful or tongue-tied, especially when they're caught off-guard or feel under pressure.

The Importance of Having an Elevator Speech

An elevator speech is the few sentences that roll off your tongue at a moment's notice that describe you and your work. You'll use this speech when you're introducing yourself to a potential funder or audience member because you never know who you'll be standing next to in an elevator or at the checkout line at the grocery store. A polished elevator speech is what you say before the elevator door opens and this potential contact disappears forever. When that person turns out to be the head of a local foundation, or someone you could invite to a fundraiser or your next event, you'll be glad you know how to introduce yourself and your work.

You'll also need an elevator speech when you call the funder. Remember that list of questions you made while reading through the grant application guidelines? If some of them are still nagging at you, you'll call the funder for some answers. But there's another major reason to call the funder: This is your opportunity for personal contact. It's much easier for a funder to reject an applicant he has never met. The tricky part is that you want to meet them but also have to have a good reason to call. After you introduce yourself using your polished elevator speech, you need to ask a smart question.

When calling a funder to ask a question, I might say, "Hi, I'm Gigi Rosenberg. I write creative nonfiction, and I'm applying for a fellowship to support finishing my memoir, *The Stone Road Home: 150 Nights in Siena.* I thought this might appeal to your organization because of your interest in ..." (Note: To finish this sentence, I need to finish my research: *Why will this project appeal to this funder?*) Then I'll end my

speech with the reason for my call: "I'm calling to ask a question: ..."
I've made sure that my question is a good one—not something I could
have answered myself by reading the mission statement or information
clearly presented on their website.

To finesse your speech, imagine you're talking to a potential
funder. Remember they're looking for artists to fund. They want to
know about what you do and why your project might be a good match
for their organization. When you present all that information clearly
and succinctly, you make their job easier.

The elevator speech for your project includes the following:

- Your name
- What type of artist you are
- The title of your project (give your project a name, even if it's
a working title)
- What medium you work in
- A brief description of your project
- A possible mention of what's unique about your project

You can't say it all, so keep in mind why the funder might be
interested in your project. Reread the "Play the Matchmaking Game"
section in chapter 1 (page 20) to remind yourself how important it is
to match your project with the funder. Think about the funder for a
minute and ask yourself, *What matters to them? What kinds of projects are
they interested in funding? What have they funded in the past that is similar to my
project? What's their mission? How does my project relate to their mission? Why
might my project be a perfect match?* After you've contemplated your project
from their point of view, you'll know what else to add to your elevator
speech to introduce your project.

How to Write an Elevator Speech

When I lived in France, it was considered rude to ask someone you'd
just met, "What do you do?" But in America, near-strangers ask this
of each other every day. This means you'll have many chances—even

several times a week—to tell people what you're raising money for. This is a good thing. Because you never know when you'll be chatting with a potential donor.

To prepare a great elevator speech, you need two things: the right words and enough practice. In just a few sentences, describe what you do; why, how, and where you do it; and when you'll be presenting it next. It can take many tries to get it right. If you are stumped, ask a colleague to describe what you do and the project you want to fund, because she might use words that you wouldn't have thought of to describe your work.

After you've finessed the words, practice this speech at every possible chance. If you meet regularly with a group of colleagues, rehearse your elevator speech at the beginning of every meeting. You may feel ridiculous at first, but the more you say the words to people you know, the less awkward you'll feel with strangers.

Sculptor James Lapp remembers the time before he had an elevator speech and how he felt when somebody asked him what he did. "I would stand there with a dumb expression on my face as I tried to sum up ten years of working on and thinking about sculpture." Now he has a succinct answer that he knows by heart:

> I'm James Lapp. I'm a sculptor working in steel and stone, combining the two—often kinetically—in ways that deal with weight, weightlessness, balance, and motion. My work is in both public and private collections down the West Coast. If you want to see more, here's my website address.

He then elaborates, but his short statement gets him started.

Artist Aviva Rahmani, who splits her time between Manhattan and Vinalhaven Island off the coast of Maine, has many chances to use her speech. When somebody asks her what she does, she says,

> I'm Aviva Rahmani, an ecological artist. I work with scientists and engineers to design solutions to environmental degradation, like global warming. I think artists can take a

lead role in solving these problems. My projects range from complete landscape restorations to museum venues that reference painting, sound, and photography.

Depending on who she's talking to, she might end her speech with an invitation to her next opening and an offer of her business card.

Artist and creative advocate Gretchin Lair really nailed her elevator speech:

I'm Gretchin Lair, a creative advocate. I like to encourage people to make art—specifically, art that's personally meaningful and truthful for you. So that's why I created Scarlet Star Studios, to promote art exploration and creative self-expression. I support visual, literary, and performing arts with workshops, groups, and independent support options. My goal is to restore hope and faith in your own abilities, to encourage you to create fearlessly and honestly.

Justine Avera introduces the two kinds of photography she does and ends her elevator speech with a question that begins a conversation:

I'm Justine Avera. I'm a photographer. I have a commercial photography practice called MorphisStudios specializing in events, portraits, and photodocumentary. In my personal work, I do a lot of landscapes and mixed-media work, including large installations where the photography helps create the environment. How about you, what do you do?

Painter Christopher Mooney introduces himself this way, concluding with information about his next show:

I'm Christopher Mooney, an oil painter. I hike around the bridges of Portland with my camera and step off the

sidewalks to get a different perspective of the city and its bridges. The photos I use are references for me to create original oil paintings. My next show is … .

Poet, author, and marketing specialist Sage Cohen wears many hats. Her elevator speech begins:

My name is Sage Cohen. For money, I write marketing content for businesses such as Blue Shield, Intuit, and Wells Fargo. For love, I write poetry and nonfiction. Recently, love and money have converged in the authoring (and successful sales) of two books: Writing the Life Poetic: An Invitation to Read and Write Poetry *and* Like the Heart, the World.

If Cohen were at a party, she might continue the conversation by asking the other person "what they feel is poetic about their life and work," she said.

When you use a good elevator speech, strangers become potential audience members, donors, and referrals. They'll attend your readings, buy your books, crowd your gallery openings, and pack your performances. Some will even write you a check. But they can only do this if they know what you do. Your elevator speech makes this possible.

When you use a good elevator speech, strangers become potential audience members, donors, and referrals.

Practice the Sacred Art of Follow-Up

Eventually, the envelope will land in your mailbox. It might be big and fat (often a good sign) or small and slim (sometimes a bad sign). It may begin with "Congratulations" or "We regret to inform you … "

But what if the decision deadline comes and goes, and you haven't heard from the granting organization? When you apply for any grant, find out the decision deadline so you know when to expect your answer. Make a note on your calendar a week after the decision deadline: "Should have heard back from Moneybags Foundation by now."

If it's a week past the deadline and you haven't heard anything, contact the funder. Say (nicely) something like, "I'm calling to check up on my application. Your guidelines said decisions would be made a week ago." At a minimum, you'll show the funder and yourself your persistence and excellent follow-up. You'll likely find out what the delay is and when to expect a decision. The best outcome of this inquiry could be what happened to an artist friend of mine. She contacted the funder two weeks after she was supposed to have received a decision and discovered she'd won the grant, but they had sent her award letter to the wrong address.

Whether you receive the money or not, you must follow up with the granting organization.

Don't Take the Money and Run

If you received the money: mazel tov! Send a thank-you note to everyone involved, including the person or people who signed your award letter. Mail thank-you notes to others associated with your grant including the director of the granting organization, and the panel members who judged the grant. If you don't know who was on the panel, contact the agency and ask if they can tell you. Hand-write your notes, and mail them with a commemorative stamp. (Don't use e-mail unless it's your only option.) If you're a visual artist, write your note on a card that features your artwork, even better if the art relates to the project they just funded. Otherwise, use professional-looking stationery —fancy or plain—with your name and complete contact information.

In your note, briefly reference your project and title (if you have one); for example, "I'm looking forward to studying solo performance with Joe Goode in San Francisco this summer" or "Thank you for funding my one-woman show *Waking the Sleeping Woman*. I look forward

to seeing you on opening night." Tell them how excited you are to have their support. Be upbeat, appreciative, and brief.

Make a habit of sending notes of appreciation. After you've been funded, you enter into a new relationship with the funder. Funders don't want to feel like all they do is cut a check; they want to be involved in your project as more than a benefactor. This is a relationship to nurture throughout your career. Send the funder updates on your project (like other grants you've won) and invitations to showings of works in progress.

After your project is completed, your funder may request a final report. This follow-up task is crucial if you ever want to receive funding again. Even if they don't ask for a final report, send a note or letter to everyone who contributed to your project to let them know how well it all turned out.

If You Don't Win

If your application is rejected, give yourself a day to pout, cry, and complain. But do not correspond with the granting agency when you're feeling defensive, angry, or unloved. Save these feelings for your good friend's or therapist's couch. Your feelings are important, but don't share them with the granting agency, ever.

Believe it or not, this rejection is still the beginning of a relationship. Playwright and actor Aaron Landsman benefitted from simply being a runner-up one year when he applied for the P73 Playwriting Fellowship. They had received four hundred applications for one residency, and he was the number-three choice. But his rejected application sparked a relationship that has benefited Landsman in many ways. P73 has included Landsman in its curated writer's group, invited him to a retreat at Yale, and signed on as his fiscal sponsor for at least one grant. They've become an advocate, and it all began with a rejection.

Within two weeks of receiving your rejection letter, when you're feeling more upbeat, send a thank-you note to the person who signed your rejection letter. Thank him for considering your application and tell him that you appreciate the feedback you received—or will

receive—and look forward to writing a stronger proposal next time. Make it a real note with a stamp, just like you would send if you'd received the grant.

A thank-you note reminds the funder, the world, and yourself that you're still in the game. Also, it's memorable. I write thank-you notes often and several times I've heard that they'd never received a note from a rejected applicant ever.

Follow Up with a Phone Call

Whenever possible, follow up with the funder to find out why you were rejected. I even follow up when my application wins, because it helps reinforce what I'm doing right.

Some granting organizations have specific guidelines for how you can follow up on an application. Follow their rules. They might meet with you in person or discuss your application over the phone and request that you call within a specified time frame. Or maybe they won't provide any feedback at all.

This follow-up meeting can provide a gold mine of information about how to improve your application next time, so even though it may be painful, don't skip this step. You may discover you had a stellar application that would have been funded except they ran out of money, or that your application was first on the waiting list.

If someone from the granting agency agrees to speak with you, be cordial—not belligerent. To break the ice, I sometimes say, "I know this conversation is uncomfortable, but the more information you give me, the more I'll learn about how to write a stronger proposal next time." This conversation is not an easy one for you or for the other person on the phone. It's bad enough having to reject

A follow-up conversation can provide a gold mine of information about how to improve your application, so even though it may be painful, don't skip it.

someone but then to have to discuss the details in person is awkward for them too. Make it easy for the other person to provide as much information as possible.

Be sure to have a copy of your application in front of you during this meeting it so that you know what's being referred to when you receive feedback. Listen and take notes. Be professional; remember that professionals know how to win and lose with grace. This is not the time to defend or explain your project. End with thank-you. This is a potential new contact.

The person providing the feedback is rarely the person who made the decision, so arguing is pointless. "You don't need to justify why you did what you did on your application," said Christa Blatchford, formerly of the New York Foundation for the Arts. She has heard rejected grant applicants argue with the person giving feedback. "The person giving feedback isn't asking you why you did it; he or she is just giving you information, so just go into it listening," she advised. Shannon Planchon, assistant director of the Oregon Arts Commission encourages all rejected applicants to follow up so she can offer constructive feedback, which sometimes means discouraging an applicant from applying if she's not a good match.

When I make follow-up calls, I sometimes pretend (to myself!) that I'm my assistant. This helps the critique feel less personal. It puts me in the right inquisitive frame of mind: *I'm just taking notes, getting the facts.* Because the more information I glean, the more I'll learn for next time.

If this feels challenging for you, rehearse the call with a friend first.

Possible questions to ask on this call include

- What would have helped make my application stronger?
- What did the winning proposals have that mine didn't?
- What were the strongest sections of my application? (Always find out what you did well.)
- Did the panel take notes? Can I see them or can you read them to me?

- What advice can you offer me as I prepare to apply next time?
- Is my project the type of project you like to fund? What would make it a better fit?

Use whatever information you receive and apply it to the next proposal. This practice greatly increases your chances of receiving funding the next time.

your assignment

Grab a timer. In thirty seconds or less, describe out loud what kind of artwork you make and what you want to accomplish with your next project. Or, create a thirty-second radio or TV ad for your project. Or, write the jacket copy for the novel or the tagline on the movie poster. What does the project boil down to? What will hook and entice your audience? Describe your next project as ad copy. Write it as a tweet. Go.

gigi's cheat sheet

- Practice your elevator speech every chance you get until it sounds natural, not stilted.
- Rehearse your elevator speech with a friend before actually calling the granting agency.
- Keep your elevator speech concise and simple: What do you do? Why might the funder be interested in your project?
- Follow up every rejection with a request for feedback.

- If criticism is hard to take, remember that you're just getting the facts.
- Thank everyone involved with funding your project or reviewing your application, regardless of whether you win the grant.
- Don't request feedback when the guidelines specifically say, "We don't give feedback."
- If you win, keep in touch with all your donors before, during, and after you create your project.

11 • fundraise strategically

Nothing on your application
excites funders more than the
money you raise on your own.

When artist Jackie Battenfield decided she wanted to write a book, she did what many artists *don't* do: She made a budget for how much her project was going to cost her to produce. "Most artists don't want to know how much it costs them to make their art," she said. But Battenfield knew that a book was a huge undertaking and that the project would take her away from her art studio and the work that earned her money.

So she sat down and asked, *What will it really cost me to write this book? What kind of resources do I need?* And she didn't scrimp on her budget. Even though she knew that her publisher would provide an advance against future royalties, she knew that advance was unlikely to pay her adequately to research and write the book. In addition, she wanted to hire an assistant to transcribe interviews and help assemble all the images she planned to include. And because Battenfield is not a writer, she knew she would need a professional editor to review her manuscript before she submitted it to her publisher.

Battenfield knew that if she looked at the actual numbers, she'd be likely to think more resourcefully about how to get her book published. So, she did a budget including everything she wanted "It was a lot of money," she said. "It was scary—$80,000."

Once she had the number, she wasn't paralyzed, she was free—free to be creative about how to earn the money to support her project. Before the book was finished, she hosted a fundraising dinner where guests paid $25 per person to support the project. She arranged to have the New York Foundation for the Arts act as her fiscal sponsor, which made her eligible for more types of grants. She researched which foundations were interested in supporting a project on the subject of career advancement for artists.

In the end, Battenfield raised $50,000, mostly from two foundations: the Sam and Adele Golden Foundation for the Arts and the Emily Hall Tremaine Foundation. Her book, *The Artist's Guide: How to Make a Living Doing What You Love*, was published in 2009.

What if your project will cost a scary amount of money—more than one or two small grants could supply? You can find a fiscal sponsor and do your own fundraising from individual donors.

Find a Fiscal Sponsor

Check out this sobering reality: Individual artists aren't eligible for most grants. According to The Foundation Center, less than 10% of foundations and very few government agencies even consider proposals from individuals without "institutional affiliation." In other words, most grants go to nonprofit organizations.

To make matters worse, grants available to individuals are usually small—a $1,500 professional development grant or a $6,000 project grant, for example. This is fine if you have a small project or use several grants to fund a medium-sized one. But what if you have a big project in mind? Filmmakers, for instance, often need to raise scary amounts of money. How do you get access to these larger amounts?

One way is to become a nonprofit organization, which means applying to the Internal Revenue Service for 501(c)3 status. But this

process is time-consuming, has associated costs, and might not fit your mission.

Another option is to find an established nonprofit organization— one that has 501(c)3 designation—willing to take your project under its umbrella and act as your fiscal sponsor, allowing you to apply for grants earmarked for nonprofit organizations. For a small fee, the fiscal sponsor functions as an intermediary between you and your grantor(s) and collects money for you. Its incentive relates to its mission in the world, which may be to help artists or may relate directly to the theme of the project you propose.

Even with the sponsor, you still have to apply for grants and plan and implement your own fundraising campaign. However, some sponsors, such as the New York Foundation for the Arts, will consult with you on fundraising and proposal writing and provide other assistance. The sponsor is legally and financially responsible for ensuring that you comply with all of the terms of any grants that you receive.

Besides giving you access to a greater number of grants and larger grants, having a fiscal sponsor has several benefits.

- Individuals who want to donate to support your work will write checks and make donations to your fiscal sponsor, not to you, making their contributions tax-deductible. This benefit will be attractive to donors making generous contributions and may give them an added incentive to contribute to your project.
- Having a well-respected nonprofit affiliated with your project gives you legitimacy. Some individual donors prefer to write checks to organizations rather than individuals, even if the money is going to the same place. Whom would you be more likely to fund: a lone unknown artist with a project in mind or an up-and-coming artist with the backing of the New York Foundation for the Arts? I'd go for the artist with the sponsor.
- Having the name of a well-known organization attached to your project may also have a psychological benefit for you. With strong support, you may feel more confident about asking for larger amounts of money from a greater number of sources.

What's the Catch?

There are a few downsides to working with a fiscal sponsor.

A sponsor takes a small percentage of the funds you raise to pay for the administrative costs of handling your donations. This fee usually ranges from 5% to 9% plus application fees and yearly contract renewal fees that range from $40 to $50.

If you're raising money only from individuals donating small amounts, it might not be worth the effort to get a fiscal sponsor because your donors won't get much benefit from the tax deduction.

Not all funders will work with a fiscal sponsor, but funders usually make this stipulation clear in their guidelines. If you're unsure, ask.

Sometimes grantors will deny a grant request if the sponsor's mission is outside the grantor's funding priorities. For example, if an environmental organization is your fiscal sponsor, a grantor who gives money to the arts but not to environmental causes might reject your application based on that criterion alone.

Beware of a contract with a fiscal sponsor whose fine print takes away your creative control over your project. I've heard of artists who inadvertently gave away their rights to their work. Ensure that all creative control of the project and copyright remain with you.

Where to Find a Sponsor

Technically, any nonprofit with 501(c)3 status can be your fiscal sponsor. Find one you trust that has experience as a fiscal sponsor—especially with individual artists—and is related to your subject matter. Procuring a sponsor usually involves submitting an application that can be as involved as a grant application, but this is a good thing. Like any proposal, this application helps you further clarify your project.

Several national organizations specialize in fiscal sponsorship for artists; four are highlighted below, along with associated costs (which are deducted from money raised for the project).

DANCE THEATER WORKSHOP ·
www.dancetheaterworkshop.org/programs/fiscal_sponsorship/faqs

- No application fee
- 7% fee for grants and donations paid by check
- 9% fee for donations made by credit card

SAN FRANCISCO FILM SOCIETY ·
www.sffs.org/Filmmaker-Services/Fiscal-Sponsorship.aspx

- Must be a member at the Filmmaker Pro level or higher
- $40 application fee
- 7% fee for all funds managed up to $100,000
- 5% fee for all funds raised beyond $100,000
- Additional 3% fee for donations made by credit card

NEW YORK FOUNDATION FOR THE ARTS (NYFA) ·
http://www.artspire.com

- No application fee
- If accepted, one-time contract fee of $100
- Annual contract renewal fee of $50
- 8% flat fee on all funds raised for the project
- Any direct fees incurred (e.g., bank service fees or postage)

FRACTURED ATLAS ·
www.fracturedatlas.org/site/fiscal

- No application fee
- 6% administrative fee (taken when donation is received)
- No fee for online donations by credit card (up to $5,000 per transaction)
- Donors can make automatic recurring monthly donations

- Can accept and process in-kind donations of equipment and materials in lieu of cash
- Any special or unusual direct fees incurred (e.g., bank service fees or postage)

The Fiscal Sponsor Directory (www.fiscalsponsordirectory.org) is maintained by the San Francisco Study Center and helps connect projects with fiscal sponsors. The website includes a resource list and searchable database.

For overachievers who crave the details of various types of fiscal sponsorship arrangements, see Gregory L. Colvin's book, *Fiscal Sponsorship: 6 Ways to Do It Right*. San Francisco: Study Center Press, 2005. The 1993 first edition is identical to the 2005 second edition except for a new, extended postscript.

Weigh In

To determine whether fiscal sponsorship is a good option, weigh the pros and cons for you and your project. Your lists might look like this:

PROS

- I'll be eligible to apply for more grants.
- A sponsor gives my project legitimacy that may help me raise more money.
- Donations from individuals will be tax deductible.

CONS

- I still have to write grant proposals.
- I must give a percentage of money I raise to my sponsor.
- I have to apply for sponsorship, which is as much work as writing a grant proposal.
- My individual donors won't care whether their donations are tax deductible.

The benefit to sponsors is association with projects they believe in and that help them fulfill their missions. Even better, they're affiliated with projects without having to do any actual work. (That's your job.) The best fiscal sponsor relationships are a win–win for both the individual artist and the organization.

Raise Your Own Money

Doing your own fundraising is the most fun, personal, and terrifying way to raise money. It also has the potential to raise *more money, much faster* than grant writing. So, like most things in life, that carry the most personal risk, it also

> ● ○ ○
>
> Doing your own fundraising has the potential to raise more money, much faster than grant writing.

has the biggest potential payoff. This type of fundraising is not for the faint of heart but don't let that stop you.

By doing your own fundraising, I mean throwing fundraising house parties, sending solicitation letters, and *asking* for money from individual people in a hundred other ways. Each contribution may be small, but the total sum may provide you with more money than a grant while making your grant application more competitive (because it shows income from varied sources).

Morrie Warshawski, author of *Shaking the Money Tree,* is a big proponent of soliciting donations from individuals, which he encourages his clients to consider. He shared the following benefits of do-it-yourself fundraising:

- It's fast and involves much less paperwork than grant writing. You should prepare a one-sheet description of your project and work samples, but it's unlikely you'd need a full grant proposal. Sometimes, you don't need either.
- Individual donations don't necessarily have to support a specific project; they can be solicited to simply fund the creation

of more art, which is the kind of funding most artists want. Funding organizations often require grant money to be spent only on a specific project, not on general operating expenses. With individuals that's rarely a stipulation.

* Unlike foundations, individuals tend to stay with you over the long haul.

The only funder who'll be with you for the life of your work is the individual funder. This means that the effort you make now is well worth it in the long run. "If an individual gives you a dollar this week, and you stay in touch with them and treat them well, the next time they'll give you two dollars, and three years from now they'll give you four dollars. They're going to be with you a long time. That's something you cannot say about any other type of funder," said Warshawski.

In contrast, "If you get one or two grants from a foundation, you're lucky. Then they're gone because they've changed their mission, their focus, they're looking for other people to fund, they want to spread the bucks," he said. Because many grant applications now require an explanation of how the project will continue without grant funding, the applicant needs to come up with a plan, regardless.

Fundraising Cures Isolation

Another huge benefit of raising money from individuals is that the fundraising itself drives you out of the seclusion of the editing suite, painting studio, or writing room and into the throngs of humanity. Showing up in the world helps you build a community of fans and supporters—a must for any successful art career. This act alone can be very inspiring to your work.

Because the funder is not distant but personal, you feel an obligation to the individual people who've donated to your project. Fundraising from individuals also has the psychological benefit of putting you, the artist, in the driver's seat. Rather than passively waiting months to hear if the grant panel funded your project, you're in motion—promoting

your project and drumming up support. You haven't put the fate of your project in someone else's hands.

Money Attracts Money

Even if you still apply for grants, raising even a few hundred dollars from individuals shows the funder that people believe in you and will pay to support your work. It shows chutzpah and determination—qualities that funders will find irresistible.

> Raising even a few hundred dollars from individuals shows the funder that people believe in you and will pay to support your work.

"But might this turn off some donors?" some newbie grant writers ask. "Don't they want to give money to an artist who really needs it? Who's a little desperate and has no other options?"

No! Funders, like anyone else, like to donate to projects that clearly are going to succeed. Nothing impresses more than an applicant's resourcefulness and creativity in fundraising. They want to see your commitment. Donors like to give money to people who are already working their asses off. Not people sitting around being needy.

Also, most funders don't want to be the only one paying for your project. They like to see that you have other means of earning money and soliciting donations. Your own fundraising proves that you believe in your project enough to stick your neck out.

"Any time you ask somebody for money, they're going to ask who else is invested," said Helen Daltoso of the Regional Arts and Culture Council (RACC) of Portland, Oregon. "And it's not as if RACC doesn't want to be the first one, but oftentimes we're the only one. But if I know that other artists are invested in you or that you've got friends who are invested in you or that you've got a couple of businesses invested in you, then all of a sudden you look valuable."

Even if you raise only $300 from your fundraising efforts, that $300 could make your application more competitive in the eyes of the funder, distinguishing you from another applicant who didn't raise any money. If two applications are equal in every other way, you win because of that one effort.

"From my perspective, I don't care about the amount of money. If you tell me you're going to send a letter to 150 people and you think you can get 100 bucks out of that, I'm excited. Individuals, friends, and family don't have a lot of money, but if you've never asked them before or if they've supported your work through ticket sales, who's to say they won't support your work through a direct donation?" said Daltoso.

It's Always Personal

The upside of fundraising from individuals is that it's personal, and that's the downside, too. Writing a grant application is "clean"—you fill out a form, mail it in, and wait by the mailbox for the answer from on high— it won't make you feel as vulnerable as asking your friends and colleagues to donate to your project. But don't be lulled into thinking that more impersonal fundraising is easier. The most successful fundraising is always personal. People give to people at all levels of philanthropy. Successful grant applicants get to know their funders and present their projects in the most personal way, whether that person is your neighbor donating $10 or a panel deciding to donate thousands.

The Power of Individual Donors

Individuals donate more money to charity than foundations and corporations put together. In 2008, $307 billion in private money was donated to nonprofits, according to the Giving USA Foundation. Of this amount, only 13% came from foundations and 5% from corporations. A whopping 75% came from individuals and 7% from bequests (which is money that people leave in a will). That means that 82% of total private donations came from individuals.

But my friends aren't rich, you might be thinking. Don't assume that your friends have to have last names like Carnegie or Rockefeller to make a donation. The Smiths and Joneses of the world donate as much as all the Rockefellers put together. More than one-half of that 84% of individual donations came from middle-class, working-class, and low-income households. And according to the latest figures form the National Endowment for the Arts, individuals donate $13.5 billion a year to the arts, culture, and humanities. That breaks down to $45 from each individual in the United States.

Of course, asking for money isn't easy. Yet, people who know you are much more likely to give you money than people who don't know you. Put yourself in your friend's shoes: Are you more likely to write a check for $25 to a friend whose work you admire or a stranger whose work you admire? I say it's the friend. It feels good to help someone you know and whose work you love.

Remember: People won't donate if they don't want to or can't afford to. Think of your asking as an invitation they are free to accept or decline.

Throw Your Own Fundraiser

There are many good ways for an artist to throw a fundraiser. Two favorites are studio parties and house parties.

Studio Fundraiser

When fine artist Phil Sylvester wanted to renovate the studio where he teaches and works with his wife, visual artist Joan Findlay, they threw a fundraising party in their studio. They invited Sylvester's students as well as their patrons, friends, colleagues, and many acquaintances.

The first step was meticulous planning, which included writing a charming and humorous invitation that made the party sound like a good time and described all the ways one could contribute. (See the "Drawing Studio Fundraiser" section to follow.) Fifty of Sylvester's students donated paintings or drawings to be sold for $40 each.

· Drawing Studio Fundraiser ·

FRIDAY, OCTOBER 9, 5–9 P.M.

This summer, we began a series of major renovation and maintenance improvements at our studio. So far, we have exposed the old-growth timber beams by removing the suspended ceiling; installed new lighting, skylights, and industrial ceiling fans; and insulated the roof. We are thrilled with the improvements. The studio looks beautiful and functions much better. Next summer, we will reroof and upgrade the plumbing.

The improvements will ultimately cost $35,000–40,000, money we don't have, and no bank in its right mind would ever lend us (bankers tend to double over laughing whenever we approach). So this is where you come in. We are asking you, the longtime supporters of this august institution, to help us with these expenses in any way you can.

On Friday, October 9, from 5 to 9 pm, we will be having a fundraiser at The Drawing Studio. There are many ways you can contribute:

1. Donate money (checks made out to The Drawing Studio). It isn't tax deductible because we aren't a nonprofit, but it will put you in a good light with whatever deity you worship. Contribution levels are

$1,000 or more: Savior Supporter—funds an honorary chair or, rather, drawing horse at The Drawing Studio. We will carve your name into one of the studio drawing horses with a pen knife (unless you prefer anonymity).

$500–999: Mammoth Supporter—wins our undying devotion and willingness to do small chores around your house. If 20 alums decide to be mammoth supporters, we'll be $10,000 toward our total.

$100–499: Serious Supporter—wins our undying devotion and sycophantic positive criticism of your work whenever you take class.

$1–99: True Contributor—wins our sincere thanks (we mean it).

2. Donate an artwork to be sold at the fundraiser. All donated works will be sold for $40. The studio walls will be covered with pieces by Drawing Studio alums. We've done this before. It is a blast and allows people to buy wonderful artwork at an outrageously low price. If you choose to donate, drop your pieces by the studio during any class time before October 9, (7–9 P.M. Tues. / 6:30–9:30 P.M. Wed.–Fri. / or 9 A.M.–2 P.M. Sat.). Unsold pieces can be picked up at the end of the fundraiser.

3. Buy a donated artwork at the fundraiser. $40 apiece for great pieces by Drawing Studio alums. Great work at a ridiculously low price. Can't beat that!

4. Buy an artwork by Phil Sylvester or Joan Findlay. As you know, the two of us make paintings, drawings, rag rugs, guitars, and amplifiers. We can show you through our work by appointment, or you can view the work that is on display in our gallery the night of the fundraiser.

As an added incentive to attend the fundraiser, Joan and Phil will publicly humiliate themselves by occasionally playing music (sometimes it's music) at the event. Joan has recently started playing the drums, and Phil, as you know, plays guitar. This will be even more fun to witness because it is mortifying to our 17-year-old son, Eoin, who may be groaning somewhere in the studio (backup vocals).

We look forward to seeing you, 5–9 P.M, Friday, October 9, at The Drawing Studio!

Sincerely,

Phil and Joan

At the four-hour open house, attendees purchased student art, T-shirts, and Sylvester's and Findlay's art; entered raffles to win classes or artwork; drank wine and ate cheese; and listened to the couple jam, with Sylvester on guitar and Findlay on drums.

Asking for money is a kung fu skill that artists need to develop as much as their art skills. Nobody gives you points for being a martyr. If you say, "I only need a bowl of rice to survive," you know that's bullshit. You need to live. You're not making as strong of a contribution to culture if you assume you're not worth it.

· JON LAPOINTE, FORMER EXECUTIVE DIRECTOR,
SIDE STREET PROJECTS ·

By the end of the evening, The Drawing Studio had raised $8,000. Sylvester credits his success to having been around long enough to have a 1,200-person invitation list. Donations ranged from $5 to $50, with people donating an average of $40 each. Sylvester's expenses included invitations and postage, printing T-shirts, and refreshments. He enlisted volunteers to sell raffle tickets, pour wine, and sell merchandise.

House Party

In 2009, Licia Perea, dancer and choreographer as well as head of the Latina Dance Project, won a $4,000 matching grant from the Los Angeles Cultural Affairs Department. The money, which she had

to match dollar for dollar, paid for choreographers, original music, costumes, and sets to create a new dance theater piece. To raise the $4,000 needed to match the grant, Perea and her three collaborators decided to throw a fundraising house party. To plan the party, they read Morrie Warshawski's *The Fundraising Houseparty: How to Party with a Purpose and Raise Money for Your Cause.*

A colleague of Perea's offered her backyard for the June event. Perea and her host invited 150 people total. Although Warshawski suggests snail mail invitations, Perea sent invites via e-mail. Her party invitation asked everyone to contribute, even if they couldn't attend, and announced a $25 entrance fee.

Forty people showed up to the party, which lasted about ninety minutes. Perea talked about her new piece of work, the company presented a fifteen-minute live performance of the new dance, and one of her board members made a concise and passionate "ask" for additional contributions.

In the end, almost one-half of the attendees contributed more than the $25 entrance fee. Donations ranged from an additional $40 to $1,000. Including donations sent by mail or through her website before and after the party, Perea raised $3,600. Because many people who couldn't attend the party still contributed, the event served a dual purpose: it was both a direct-mail solicitation and a fundraising house party.

To ensure your house party is successful, make it an event people want to attend and be clear in your invitation that it's a fundraiser. This ensures that everybody attending is open to making a donation. Ideally, you'll have the party at an enticing location that relates to your project. At a minimum, have it at someone else's home besides your own.

In *The Fundraising Houseparty*, Warshawski offers step-by-step instructions for throwing a successful fundraiser in a home. At the event, you (the artist) make a brief presentation, and a host or peer— "someone articulate, enthusiastic, and respected"—asks everyone to make a contribution.

A house party will catapult your career forward. It will show you just how many people support you and your work. Will you feel uncomfortable? Of course. If you don't feel a little uncomfortable, then you haven't taken a big enough risk.

Ask in Writing

Several years ago, I wanted to attend an expensive workshop taught by Spalding Gray. I was performing autobiographical monologues and longed to study with the "granddaddy" of the confessional solo performance. To finance the trip, I applied for a professional development grant from the Regional Arts and Culture Council.

I heard the competition was stiff and I wanted my application to stand out. Showing that I had raised some money on my own would make my application more appealing to my potential funder. They would see how much I wanted to go and how many others believed I should go, too. The amount of money I raised would be the proof. I also thought that because my colleagues and family might have heard of Spalding Gray, they might be excited about funding my study with him.

It took many drafts to polish my request letter, which I sent to about seventy friends, family, and colleagues who I thought would be excited to support my work. (See my January 9 letter on page 165.) I printed the letters, addressed the envelopes, attached a commemorative stamp to each one, and walked nervously to the mailbox outside my local Safeway. After I heard the envelopes thud at the bottom of the metal box, I wanted to stick my arm down the slot and grab them all back.

When I arrived home, I logged onto my computer and discovered, within minutes of my mailing those letters, that Gray had been reported missing. By the time my letters arrived in people's mailboxes, Gray was presumed dead.

I was devastated. Not only had I lost one of my favorite artists, but I was cringing from what I assumed was a misguided fundraising effort that had taken so much courage to launch.

As it turned out, many people sent me money anyway, trusting that I'd find another workshop. For weeks after I'd mailed those letters, I opened my mailbox to find notes with checks in them written out to me. It was thrilling! I'd asked for donations ranging from $10 to $50. The smallest donation I received was for $20, and several were for $50.

January 9

Dear Friends:

I'm writing to share some good news and to ask for your help.

I just found out that I am accepted to a weeklong performance workshop taught by the legendary Spalding Gray. The class is designed for performers to hone their storytelling and to develop a work-in-progress. Only 25 artists are accepted into this intensive program, so I'm thrilled that I got in.

As many of you know, I've been writing and performing monologues for the past four years, working with directors Susan Banyas and Michael Griggs. My solo performance has been featured at On the Boards in Seattle and in Portland at the CoHo Theater, Lewis and Clark College, Pacific University, Performance Works NorthWest, and Stark Raving Theater's New Rave Marathon.

The workshop takes place this March at the Omega Institute, and the entire cost of attending is $1,500. I'm applying for a Mayor's Creative Initiative Grant that could pay up to $750 of this amount. So, I need to raise at least $750 more. And this is where your help comes in: I'm turning to you, my community of friends, family, and colleagues to ask you to donate between $10 and $50 toward my $1,500 goal. I know this may seem a little odd, an individual asking for money to attend a workshop. But there are few grants that support professional development for artists, and this year's arts funding is especially scrawny.

I'm so appreciative of the generous contributions you've all made to my work in the past by attending performances, hosting readings, providing critical

feedback, and offering encouragement. Your support, then and now, is crucial to my development.

Spalding Gray's work has inspired me for years and I feel that this workshop will enable me to sharpen my writing and performance skills and take my work to the next artistic level. I'm excited about this opportunity to study with the granddaddy of the autobiographical monologue.

Thanks so much for considering this contribution,

Gigi

In the end, I raised $350, which I used to attend a workshop with voice teacher Richard Armstrong at the Banff Center for the Arts. It was the best workshop experience I ever had, financed by me, my community of support (See my September 20 thank-you letter on page 166), and a grant from the Regional Arts and Culture Council.

September 20

Dear Friends and Donors:

I just returned from The International Voice Workshop at the Banff Centre in Alberta, Canada, and I wanted to thank you once again for your donation which helped fund my studies there. It was an incredible workshop.

The Centre is nestled in the Canadian Rockies, so the setting was breathtaking. My 11 classmates ranged in age from mid-20s to late 50s and were a mix of performance artists, dancers, opera singers, and actors. Within the first morning, our teacher, Richard Armstrong, had us vocalizing and dancing as an ensemble. Then for three days, he led us through a rigorous vocal workout emphasizing range, resonance, effective breathing, and body alignment.

Also, after you sent your contribution, I applied for a professional development grant from the Regional Arts and Culture Council and was awarded $1,100 to add to the funds I had already raised from all of you.

So, your donation did double duty: It helped me get to Banff, and it helped secure additional funds to cover the cost of the entire program. Thank you so much for your support! I look forward to seeing you soon.

With warmest regards,

Gigi

Creative Fundraising

Fundraising strategies do not end with house parties and solicitation letters. Ideas for how to fundraise are as limitless as your imagination. Artist and professor Karen Atkinson has conducted, by her own admission, many "oddball" fundraisers over the course of her thirty-year career.

One project, titled *For the Time Being*, involved twenty parking meters set up in site-specific locations all over Los Angeles. Bystanders encouraged by the brightly painted meters paid twenty-five cents to listen to fifteen minutes of "audio art" that played from cassette recorders Atkinson installed at the base of each meter.

"I collected one quarter at a time and raised $10,000," said Atkinson, who teaches at Cal Arts and runs GYST to help artists succeed at the business of art. The original project was funded with a grant from Los Angeles Cultural Affairs Department, and the money she raised from the meters helped finance a last show for artists with AIDS. So her project combined grant money and her own fundraising while generating funds to finance future projects.

Websites like www.kickstarter.com provide ways for you to take your fundraising to the Internet. For more ideas, read the excerpt from Atkinson's newsletter detailing the many variations of fundraising ideas and events, Fundraising Without Grants, which follows.

The following article was written by artist and coeditor Karen Atkinson and excerpted from the ARTISTs AT WORK newsletter, published by GYST, an artist-run company for artists. Atkinson suggests enough ideas for a lifetime of fundraisers.*

Fundraising Without Grants

Fundraising can be a daunting task, and writing grants requires a lot of time and effort. There is a lot of competition for a small amount of funds. Coming up with other strategies to raise capital is essential for contemporary artists. The more diverse your funding sources, the more stable your practice will be. Get creative about your fundraising ideas. Do searches on the web to see how other artists and organizations raise funds, and if you want to write grants but need more guidance, consider using a fiscal sponsor as a partner. Ideas to consider include the following:

Film screenings. Screen a film at someone's house, in a parking lot, storefront window or other site. Sell tickets and ask everyone to bring a beach chair. In addition, sell popcorn to the audience for additional revenue. If you are raising money for a new film, showing an old one that is really great might inspire those who like it. You might also screen a short example of the current film you are working on.

Performance. Hold a performance at someone's house or other venue. Sell tickets. Use a theater on a dark night. Do it in public.

Sales of artwork. Have an open studio tour, or make artwork available on your website.

Services. While an old standby, events such as the car wash, bake sale, and other ideas might be updated to make it more interesting or educational.

Auctions (of services). While art auctions are always taxing on artists (who are perpetually asked to give everything away for free), there is no reason why you have to auction art in order to make money. Art-related services can be auctioned off, such as framing, crating, photography, documentation, etc., and auctions can require a minimum bid to ensure that the artist gets a cut of the sale.

Block parties. Another take off on the house party idea: Get a permit and block off your street for an event, or find a public park and create an event.

Yard or garage sale. Got stuff you can sell? Collaborate with other artists to do a giant yard sale or studio sale. Market it to other artists as a studio sale, and sell all those supplies you have collected but do not use anymore. You would be surprised at how many artists need discounted supplies and how great your studio will look with all that extra room.

Money-catching machine (pneumatic cash transport mechanism). Machine Project in Los Angeles created a money-catching machine that they describe as follows: "Bring cash money to put in our ramshackle and potentially dangerous pneumatic cash transport mechanism. A network of clear acrylic tubes connected to a high-powered vacuum system running along the ceiling of the Machine Project will pull proffered dollars right out of your hands, with little to no effort by us and much amusement on your part." Built and installed by Mark Allen, Ryan O'Toole, and Brian Tse. No one can stop with just one dollar.

A new twist on events. While some events have been around a long time, consider a new twist to them. Side Street Projects in Pasadena, CA, has put on a Phantom Ball for 15 years which "takes place" on April 1st (no foolin'). The actual event does not exist, and you get to choose something you have been wanting to do for a long time instead of dressing up and going to another chicken dinner! But in this case, when you buy a ticket to this nonevent, you get a "commemorative photo" as your

souvenir of the event you did not go to created by a fairly well-known or up-and-coming artist. Sight unseen, you get an image from the artist as your "party favor." After the event, when the image is unveiled, the price for the image doubles. In 2010, at the 17th Annual Phantom Ball, tickets cost $175 each. After the image was unveiled, you could purchase it for $350.

Donation button. Have a website? Consider adding a donation button to the site for a specific project. Not a nonprofit? Then look for a fiscal sponsor.

Product sales. You may have a creative idea for a product that relates to your project, such as a CD of your music, video of your last performance, books, artwork, etc. Have a one-day sale and include every artist you know who has a CD of music, video, or performance. Or have a party. Most artists like to go to parties, and why not have some things for sale?

Dinners. Create a special dinner for donors. Hire artists to perform, read poetry, or provide other entertainment that relates to the project. Invite a special guest, such as an important artist or author. I have been to all-white dinners (all guests wore white, too), dinners where the food is so creative you can't tell what it is, and performance dinners.

Make a wish list. Instead of writing grants to get "things," consider going to the source. Arrange to work with a fiscal sponsor if they need a tax write-off. Send your wish list along with a letter requesting money as an option for those who don't have the cash to spare, but just might have something else you need to have or borrow. I once got 20 parking meters donated from a national company. This was crucial, since you can't buy a parking meter at your local store.

Cook-off. Lots of artists cook. Have an event like a Chili Cook-Off, where folks buy tickets to taste all the different kinds of dishes. Maybe you can relate the dish you cook to your project.

Partnerships. Consider creating partnerships with other businesses or nonprofits that can help you get things done for your project. They don't

have to agree to show the work but may help you with contacts or other support. Find an organization or business that is interested in the same ideas you are.

Paid ads. You can solicit paid ads for your website. Use Google Ads as a way to make life easy. For every click, you get paid.

Repair items and resell. Consider taking in donations such as used tools, bicycles, or other items; cleaning them up; and reselling them.

Rich uncle or aunt. Say you have a rich uncle who has agreed to give you some funding for your project. If he needs a tax write-off, set up a fiscal sponsorship with a nonprofit so he can get the tax write-off and you can get the funding.

So, the idea here is to be creative about donated- and earned-income strategies to help diversify your arts funding. Funders love this entrepreneurial spirit, and artists benefit from more consistent cash flow. Think smart, act creative, and bring in money and supplies.

Believe in Yourself

Fundraising forces you to believe in your project enough that you're willing to ask others to help you create it. This process makes you clarify your project, consider your audience, and create the highest quality work. You need to do these things anyway, so fundraising speeds a process that's already

Fundraising forces you to believe in your project enough that you're willing to ask others to help you create it.

under way. It can be scary, but no scarier than showing up at the writing desk, art studio, or empty stage. You found the courage to be an artist, summon the courage to finance your artistic vision.

Imagine the difference between receiving a check from a foundation in the mail and getting $25 in cash from an individual who hands it to you in person. Individual fundraising connects you more not only to the community but to the responsibility of making the work really happen.

· MORRIE WARSHAWSKI, AUTHOR AND CONSULTANT ·

your assignment

Put on your party hat! Brainstorm creative ways to invite people to invest in your work and your future as an artist. What ideas would be most fun and energizing for you to implement? What fundraising strategies make a perfect match for the project and for your capabilities? What are you waiting for? Go make money.

gigi's cheat sheet

- If you need to raise a scary amount of money, find a fiscal sponsor.
- Scrutinize potential fiscal sponsors as thoroughly as they scrutinize you.
- Make sure your fiscal sponsor arrangement will be a win-win situation for both of you.
- Use your fundraisers to enlarge your community and build your audience.
- Pick a fundraising event that fits your personality and your project.
- If you throw a house party, follow the advice of those who've succeeded before you.

12 • overcome psychological roadblocks

Of course you need talent.
But what you need as much
as talent is tenacity.

On the first day of class with his advanced art majors, artist and professor Marc Dennis walks into the classroom and slams a stuffed manila folder as thick as a phone book onto the drawing table. "This file is filled with rejection letters," he says. The students stare, wondering if he's serious. "This is what you need to get used to if you want to be a successful artist," he says. "Being an artist is about getting your work out there and being able to handle the hard hits from rejections. Not everyone is going to understand or appreciate your art."

He tells his students that the harder they work, the more they'll want to get their work into the public eye, and each time they do, the risk of being rejected increases. But he assures them, "Based on my experiences, with hard work and rejection also comes desire, and with desire comes confidence, and with confidence comes perseverance, and with perseverance comes success."

Nothing worth anything comes easy.

How to Handle Rejection and Thrive

Rejection comes with the territory. It's part of being in business. Sometimes you ask for some-
thing and the answer is "no."
In fact, the answer is often no.
If you aren't getting rejected
many times a year, you aren't
applying for enough grants, or
you aren't pushing your bound-
aries. Rejections are a sign that
you're working your edge.

> ● ○ ○
>
> If you aren't getting rejected many times a year, you aren't applying for enough grants.

Artist and professor Melissa Potter, who teaches grant writing nationally, receives about one grant for every five she applies for. That's four "no thanks" for every "yes!" All that rejection can be hard to take. It often feels personal, even if it never is. None of what I tell you here will make any difference when you get rejected, but remember that until you ask, you don't know why. (See "Practice the Sacred Art of Follow-Up" in chapter 10, page 141.) So refrain from relentless inner monologues as in, *I never win anything, I'll never amount to anything,* and *I'm just a third-rate loser artist.* Even if it's true, it won't help—it'll just stall your progress even more.

Sometimes a rejection isn't "no" but "not now." I know an artist who applied seven times for the same grant. Finally that eighth year, it all came together—the right project and a panel that loved her work— and she received the grant.

Remember that the panel that reviews your work is composed of people, and because they're human, they have quirky tastes. Maybe they just didn't like watercolors or first-person narrative or cement murals this year. It isn't personal; it's just bad luck.

I don't advise dwelling on your disappointment, but I do recom- mend that you let yourself feel disappointed for a minute or two—a cou- ple of days at most. When I'm rejected I don't want to feel sad or mad for even a millisecond. I shove my disappointment aside, but the rejection

sticks in my throat and can lodge there, unmoving, for days. Ignoring it takes enormous energy away from what I could be creating next.

To move on after a rejection, call one of your buddies and share your disappointment. Remember your team? Call someone who can say, "I'm sorry. What a disappointment. Those jerks don't know what they're missing." No matter what, don't let rejection keep you from returning to work after you've felt the sting. You're a prizefighter. Rejection knocked you down. Get up again. Don't quit. No matter what.

In his essay *Go the Distance*, in *Poets and Writers* (Nov/Dec 2009), author Benjamin Percy bragged that "whole forests have been pulped to print the rejection letters sent my way."

"I wasn't offended. I was inspired," wrote Percy, who taped the rejection letters to the wall near his desk. "The wall of shame, I called it. The way I saw it, everybody thought I was a bum, like Rocky. And every morning, when I woke up to hammer the keys, I would stand there, coffee mug hot in my hand, staring at those comments. My thoughts were somewhere between *I'm going to get you* and *I better do better.*"

Percy writes ten stories for every one that gets published. "Each SASE that arrives in your mailbox, I know, is like a fist to the face," he wrote. "But you've got to see through the blood—you've got to keep breathing raggedly through those broken ribs."

Get used to rejection; it's not personal. Apply to a lot of things. You might need to apply to fifteen or twenty things before you get one grant. In no other industry would people take the fact that they didn't make a sale as a personal reflection on them.

· DREAD SCOTT, VISUAL ARTIST ·

"There are so many reasons the SASE might have shown up in your mailbox ... Regardless, you must develop around your heart a callus the size of a speed bag," he wrote. To ease the blow of rejection, aim to have many proposals out at one time so that "no" to one proposal is only one loss. It doesn't mean your whole career is down the drain. Just as financial advisers counsel diversifying investments and businesses thrive by having several income streams, you the artist need to have many proposals in the pipeline. If you don't win one, there's always the next one, and there's always next year's deadline.

Rejection helped musician and sound artist Ethan Rose expand his notion of his audience. After being rejected on his first grant application, he followed up with the granting agency and found out that they wanted to know not only who his audience was but also how he planned to expand his reach. Until that rejection, he hadn't thought much about his audience at all. The next time he applied for the grant, he worked hard to define his audience, describe his marketing plan, and explain how he planned to expand beyond the usual crowd.

This rejection led Rose to not only prepare a stronger application but also to consider his audience more during the creative process. Questions of audience forced him to ask, *How can I not only invite them to attend but also affect them more profoundly during my performances?* Rejections are a "subjective reaction to what you're doing. Some people won't like it. You'll never make anything that'll please everyone all the time. If that's your goal, you're dooming yourself from the beginning," he said.

Don't be doomed. Use the rejection to learn. That's what professionals do.

Surviving Your Own Jealousy

I ran into a neighbor—somebody I didn't think had one creative bone in his body—who told me he just landed an agent for his novel. The next time I saw him, he reported that two New York publishers were in a bidding war over his work. Meanwhile, a distant cousin with no prior art training takes up painting and calls to tell me she's selling her

paintings for $300 to $500 each. "It was so easy," she purrs into the phone. "I just did them for fun, called a gallery, and they sold."

It shouldn't be so easy for these people, I think. Look how much I've suffered for my art, and she just picked up a paintbrush and checks arrived in her mailbox. We've all been there—everything's going fine until you hear about someone else's success. If you looked at the roots of your hair, you might see green. The feelings of envy are monomaniacal; you can think of nothing else.

Try to do something creative when in a state of envy and you'll find it's almost impossible. To be creative, you have to go back home, back to yourself. In a state of envy you're focused on everyone but yourself: *If I can't have it, nobody can.* When you find out a friend received the grant you wanted and the jealous monster threatens to bar you from your studio, call another friend to rant. Ride through the storm. The more I let the envy rock me, the faster I move through it.

If none of your friends answers the phone, take notes. Describe the physical state of intense jealousy. When I'm in a state of envy, my body is on fire. I don't want to do anything. I don't want anyone else to have what I don't have. Often when I dig down to the root cause of my envy, I'm frustrated. It turns out, the neighbor who landed the agent wakes up at 5 A.M. to work on his novel every day before heading to work. The cousin selling her paintings takes a joy in the work that I don't feel right now. She seems in love. She's spending every free minute at the easel working. She doesn't care about rejections; she just wants her work out there. She's free in a way I'm not.

●○○ ◯ ●○○

If you showed your work to twenty artists and ten said it was brilliant and ten said it sucked, would you give up your career?

· CAROLL MICHELS, CAREER COACH,

ARTIST-ADVOCATE, AND AUTHOR ·

My envy shows me where I'm not being true to my artist: I'm not spending the time at the writing desk. I'm not letting myself love my writing like the painter loves her painting. If I loved it more, made it more fun

Let your jealousy remind you of what you want.

to do, maybe I'd spend more time doing it. My envy makes me ask, *What do they have that I want? Am I doing everything I can to get out of my own way?*

Let your jealousy remind you of what you want. After it runs its course, take what you learn and reclaim the work that is important to you. Let your envy guide you to a more fun way to work, to treat your artist with respect, and to design your creative life so you can't wait to get back to it.

What would it take to do that? Learn from successful people. How did they do it? What can you learn from how they work that will help you? And remember, no matter how much you've evolved personally, envy always lurks. You probably won't grow out of it. Best case, you'll become faster at moving through it.

Recently, I made a rule: No checking e-mail before writing. I was following this rule until one day, for some reason, I checked my e-mail first thing. I had received a mass e-mail from a writer I don't know very well announcing the launch of her latest novel—her third. (Her first two had been received to acclaim.) I sat at my computer, my skin turning green. I felt sick with jealousy at the thought of the writer at her desk, writing, like I should be doing right now instead of reading e-mail and tending to a jealous fit.

Crawling around in the dank basement of my jealousy, I thought, *I want what she has.* I felt myself at a crossroads. One way descended into more jealous rage. The other way was lined with questions: *Can I use the image of this writer at work to spur my own writing? Can I transfer the energy of this envy back to my own work? Can I use this jealousy for creation rather than destruction?*

Yes.

That was he answer that came to me. The jealousy wasn't clinging to me; I was clinging to it. The jealous monster helped me close my e-mail program and open up my latest essay. He flew off, and I went back to work.

Surviving Other People's Jealousy

After she landed her first book deal, author Ariel Gore noticed another form of jealousy, this kind from her friends. "I had always heard about fair-weather friends, but now I saw that there were 'stormy-weather friends' as well. A lot of my friends only liked me when we were all drunk and bonding over our poor luck. The first flush of dreams coming true, and they bailed," she said.

If you thought your own jealousy was the only kind you'd have to contend with, you may be surprised when you discover that the more you and your work come into the world, the more you'll encounter the jealousy of others, even people who are now your cronies. Did you make a silent pact that none of you would succeed, even though it's all you ever talk about? If you're the first one to gain a measure of success (win a grant, for example), then you may find that your old friends don't want to be friends with the new, successful you.

You need to find new friends.

The most shocking jealousy will come from people you presumed were more successful and secure than you. Sometimes teachers, even mentors or consultants you've hired may express their jealousy in subtle or blatant ways. You'll call to tell them the good news and their response is limp. They remind you of pitfalls or warn you of the downside. A friend of mine calls this being "slimed." You'll know it when it happens because you'll feel worse after sharing the good news. Or the news won't sound so good anymore. You'll feel too big for your britches.

Once after I'd received a prestigious assignment, I was chatting with a former professor and successful artist, someone who'd not only supported me but promoted my work to his colleagues. Since I'd been his student, I had grown into my own career as a writer.

After I shared my success, he was suddenly full of gloom. He reminded me of all the ways the assignment would be hard, if not impossible, and said he'd heard that my new colleagues could be difficult to work with. Fortunately, after this encounter, I spoke to a trusted friend who helped me recognize my former professor's possible jealousy and I realized that my relationship with him had changed. I was no longer his student.

Witnessing someone who previously supported you transform into a roadblock (or a wet blanket) can be surprising and bewildering. If it happens, recognize it for what it is. We're all human—susceptible to jealousy. It's an occupational hazard for some teachers that they feel most supportive of students and underlings. Sometimes when the disciple matures into a colleague, the mentor feels threatened and can't be supportive. I've heard of famous artists who discourage talented students from pursuing a career in the arts because they want to quell the competition.

It's an awkward transition when the student becomes the colleague. If your once-enthusiastic mentor or teacher doesn't take it graciously, it may be best to avoid this person now. It's a sad loss. But to grow means to change, and to change means accepting some losses along with the gains. Don't let the sorrow of loss hold you back.

Resisting the Grandma of Resistance

Sometimes my resistance to starting a project feels like cement shoes. When I'm stalled, all I can think is, *No how. No way. I don't want to make that phone call, write that e-mail, begin that grant application. And nobody's gonna make me.*

I have many tricks up my sleeve to break my own inertia. I set a timer for ten minutes (or five, if ten's too long). I ask myself, *Can I suffer with this task for ten minutes?* Usually I can. Then, after I start, I can barely remember how much I didn't want to start.

Does Suffering Inspire Great Art?

○ ◉ ●

What if you've done everything right—you hammered out your mission, you applied for the grant, you joined an artist group—but you still feel stuck and miserable? Now what? Does it mean that as an artist, you've signed on for a life of suffering? I say no.

For some of us, deeper work is required to uncover and explore what's really getting in the way. It rarely has to do with the one rejected grant application or the one lousy artist group. If you find yourself stuck, don't suffer longer than absolutely necessary: Seek out a therapist or counselor for one-on-one psychological support when you need it.

I've heard of artists who fear that too much psychoanalysis leads to too much happiness, which leads to less quality work. They fear that therapy may rob them of their ideas or the pain required to make art. *Isn't all art born out of struggle?* That's the myth of the tortured, brilliant artist. I haven't found it true among working artists. Instead, I've noticed that the more psychological work, the more productive, happy, and financially successful the artist.

Several books listed in Appendix C: Additional Resources to Support Your Career may inspire your thinking.

My resistance shows up dressed in many guises. The scariest one is the dark figure of the old-world grandma, wringing her hands and singing her worries, "What if your writing is bad? What if you're the laughingstock?" She'd like me to get a real job, stop rocking the boat, stop lifting the rug. She tells me,

- Sticking out is bad.
- Showing off is wrong.
- Don't outrun your famous artist mother.
- Don't outshine your painter father.
- Don't make others jealous.
- Don't tell family secrets.
- Don't sit in your studio alone making something that's yours.
- Don't be different.

She wants me in the group, the family, the circle, at all costs.

The common self-help remedy for dealing with resistance is hand-to-hand combat, no matter how she's dressed. Fight dirty. Fight hard. Fight fast. Once she has one black, lace-up shoe in your door, forget it—it's over.

I've tried this. Ignoring her. Telling her to shut up.

And it's never worked.

The harder I shove her away, the more incessantly she taps at my window. "What if" begins her every sentence, always a question of doubt or fear. The harder I push her, the harder she pushes back. She stops me dead in my tracks. Which may be the whole point.

So one day, I let her in. To do this, I grabbed a pen and pad and wrote out my conversation with her. She entered slowly, shaking off her umbrella, scanning the room, looking at how I live. "I want you to be comfortable, to fit in, be safe," she said, her eyes wandering across the sculptures atop the upright piano, the paintings and drawings on the walls, the dust breeding under the sewing machine.

"Safe is the same as everybody else," she said. That was safe for her, back in the old country. A country that no longer exists.

"Artists break down the status quo," I told her. "We peel back the rug, dig up what's been buried, poke at taboos, paint paintings that make no sense, write cacophonous symphonies. We ask the questions everybody's thinking but afraid to voice. That's what artists do."

"Oh," she said. "I didn't know."

She stayed a little longer. I listened to her worries. I thanked her for her concern. I told her that I know she just wants me to be safe.

She suggested I put up a pot of soup. I complied. The more I listened to this grandma of resistance, the more I felt her protecting me from something I didn't want to see. *What was it?* It took a long time to discern.

When I show up to the studio to make something, I leave home for good. I abandon my jobs as mother, wife, daughter, sister, friend, teacher. I arrive as inspired, angry, ecstatic, miserable, irritable, wretched, blessed writer.

What's hiding is what I'm looking for.

I'm not waiting to have had a happier childhood. I accept that I didn't get everything I wanted. I didn't even get some things I really needed. But I'm not waiting for anything to be better or different or more acceptable. I make art out of the losses.

I find it touching that this grandma is trying to protect me. She doesn't want me to feel alone, maybe even bereft. But what she doesn't know is that until I feel the loss, I can't write the harmony or the sonnet, or stage the performance installation. And that's what I'm here to do: to paint this painting, taking all of what I did get and leaving behind what I didn't want. I'm here to tell the story of the leaving, of the taking, of the letting go.

Grandma is my grief for all that was lost or never found. When I ignore her, she rises up. The sooner I sit her at my table and let her speak, serve her a bowl of soup, the faster I can get back to work. When I haven't heard from her in a while, I think, *Well, good—she's gone.* Then, the next morning, grandma arrives bright-eyed demanding I stop writing, right now. Her fresh presence used to depress me. I'd think, *Uh-oh. If she's still here it must mean that I've made zero progress."*

No.

As a counselor once told my future husband and me when we were wondering if getting married was a good idea: "It doesn't matter how many problems you have. What matters is how well you handle your problems."

So, the same advice translated to this situation is: It doesn't matter how many times Grandma shows up demanding I stop writing. I won't shove her away. I let her speak. And I keep writing.

Some days, she quiets down. Some days, she won't shut up. I notice that the more riled up she is, the closer I am to the hot white center of whatever I'm writing. No matter. She begs me to stop and I keep on.

your assignment

The next time you show up at your studio to work or sit down to dig into a grant application and your resistance rises up, stop. Grab a pen and paper and write down your conversation. Let that negative voice have its say. Answer her as best you can. Then, thank that voice for its concerns and dive back into the work at hand. Repeat as often as necessary.

gigi's cheat sheet

- Don't let fear of rejection make you quit.
- Learn everything you can from each rejection.
- Let yourself feel the sting of rejection and then get back to work.
- Use your jealousy to inspire you to return to the work you really want to do.
- Beware of other people's jealousy masquerading as good advice or help.
- Surround yourself with colleagues and friends who support your big career.

epilogue:
make art

Someone once confided in me that she stashed her finished grant application underneath a statue of the Virgin Mary overnight before submitting it. Whatever you do before finally sending it in, deliver your application on time—or, better yet, early—then forget about it. Go back to your work, your job, your other proposals and income streams. Proceed as if you'll receive funding and as if you won't.

For success with grants and just about anything else in life, it's persistence that makes the difference—not blind ambition but quietly showing up, day after day, to make art and to thoughtfully get your work out into the world. Practice taking small steps consistently in the direction of your goals, despite the inevitable ups and downs and the discomfort of individual moments. When you lose your way and it's blustery January, envision the warmth of the end of June. Where do you want to be when strawberries are in season? What do you want to have accomplished? What deadlines will you have met by then?

Foster collaboration and partnerships to keep you not only productive but also connected and happy. As a smart artist once told me, success is a social activity.

Do whatever you need to do to foster less chaos and more calm, steady work so that you continue to grow your body of work. If this means a major reorganization of your work and home life, so be it.

An art career requires the skills of the small business owner and the savvy of the entrepreneur. What will sustain you over the hills and

through the valleys of that journey to a year from today? to five years from today? to fifty years from today?

Write a letter to yourself from your eighty-year-old self. From the perspective of the older you, what advice do you have about what's most important? What don't you want to miss? What's worth fighting for? What's best abandoned? The older you may have age spots and gray hair but you have wise eyes too. Let your eighty-year-old self tell you what mattered in the long run.

Above all else: Make art. The world needs your song, story, play, photograph, sculpture, painting.

Writing grant proposals will be only one part of your big art life. Use the process to foster your dreams and to carry on that conversation between you and your art, and your art and the world.

Where to Find Grants and Residencies

Grants

The following books and websites feature useful information for individual artists, including information on specific grants. I have included the well-known ones as well as my personal favorites. As you research, you'll find even more resources to add to this list.

FOR ALL ARTISTS

ArtDeadline.com. A comprehensive list of competitions, grants, fellowships, festivals, residencies, and other funding opportunities for artists in all disciplines. Fee-based subscription. www.artdeadline.com

Art Opportunities Monthly. A monthly newsletter including verified grants, competitions, residencies, and scholarships. www.artopportunitiesmonthly.com

Artist Trust. A Washington-based arts organization. Its "Professional Resources" section lists grants available nationwide. www.artisttrust.org

Creative Capital. Founded in 1999, this foundation's mission is "to support artists pursuing adventurous and imaginative ideas, drawing on venture capital concepts to provide funding, counsel, and career development services." A unique and inspiring organization. www.creative-capital.org

Dillehay, James. *Directory of Grants for Crafts and How to Write a Winning Proposal.* Torreon, N.M.: Warm Snow Publishers, 2000. A comprehensive listing of funding sources for craft artists and step-by-step instructions on proposal writing.

Foundation Center. The nation's leading authority on philanthropy. Publishes numerous books on grant writing and grant seeking, including *Foundation Grants to Individuals* (Phyllis Edelson, ed., 2008).

The jam-packed website offers a wealth of information on grants, funders, statistics, and more. www.foundationcenter.org/getstarted/individuals.

Foundation Grants to Individuals Online. The Foundation Center's Grants to Individuals search engine offers detailed descriptions of more than 8,000 foundation programs that fund students, artists, researchers, and other individual grant seekers. Updated quarterly. Subscription is $19.95 per month. Look for free access at your local library or a nearby Foundation Center office. www.gtionline.fdncenter.org

Grants.gov. A listing of federal government grants. www.grants.gov/search/category.do

McDonough, Beverley (ed.). *Annual Register of Grant Support: A Directory of Funding Sources.* Medford, N.J.: Information Today, annual. This comprehensive (1,200-page) resource lives up to its title and costs more than $250. Find the current edition in your library's reference section.

Michigan State University Libraries. An extensive compilation of links to grant-making foundations, databases, and books relevant to individual artists and others seeking funding. The site is frequently updated and offers a special focus on scholarships. Access is free. http://staff.lib.msu.edu/harris23/grants/3subject.htm

Mira's List. Mira Bartók's blog for artists, writers, composers, and other artists. Find up-to-date information, resources, and deadlines for grants, fellowships, and international residencies along with Mira's encouraging and inspiring posts. www.miraslist.blogspot.com

National Assembly of State Arts Agencies. A good resource for researching state-supported grants for artists, providing links to state arts agencies and a range of publications. www.nasaa-arts.org

National Endowment for the Arts (NEA). Explore available grants by artistic discipline or field, and browse the list of fifty-six state and regional NEA Partners. Note: Most grants are limited to organizations. www.nea.gov

New York Foundation for the Arts. An extensive national directory of awards, publications, and services—including fiscal sponsorship—for artists. This incredible resource is updated daily, and access is free. www.nyfasource.org

Regional Arts and Culture Council (RACC). The resource section of the RACC website contains useful information about residencies and competitions available nationwide but is most useful to residents of the Pacific Northwest. www.racc.org/resources/announcements

Dramatists' Sourcebook. New York: Theater Communications Group, 2008. Indexed directory of prizes, fellowships, and residencies, with a calendar of submission deadlines.

WomenArts. Founded in 1994, this nonprofit organization is dedicated to helping women artists find the resources to do creative work. Provides fundraising basics, lists of funding resources for artists, and other services. www.womenarts.org

For Musicians/Composers Only

American Composers Forum. Lists residencies, grants, and competitions. www.composersforum.org

Opera America. The National Service Organization for Opera offers a fee-based list of grants and competitions for opera artists, including composers, librettists, and singers. www.operaamerica.org

The American Music Center. The most relevant is a composer assistance program. They also have a fund to assist dance companies in using live music. Any musician or composer working with a dance company might be interested in this program. www.amc.net

The Aaron Copland Fund for Music. Funding supports programs that increase the exposure and promote the recording and distribution (including online) of contemporary American composers. www.coplandfund.org

For Visual Artists Only

College Arts Association (CAA). CAA offers a database of awards, grants, and fellowships and a list of opportunities "for artists, scholars, museum professionals, educators, and other members of the arts community." Also, through its own Professional Development Fellowship Program, the CAA offers artists a one-time $15,000 grant without contingencies. www.collegeart.org/opportunities

For Writers Only

Funds for Writers. Hope Clark offers a comprehensive monthly newsletter for $12 per year that lists contests, awards, grants, and fellowships. Her e-books cover many aspects of funding and writing for publication. www. fundsforwriters.com

PEN American Center. The Grants and Awards Database, which comprises more than one hundred grants, fellowships, scholarships, and residencies for writers, may be purchased by subscription for $12 per year. www.pen.org

Poets & Writers. List of current and verified grants, awards, and competitions from "the nation's largest nonprofit literary organization" and publisher of *Poets & Writers* magazine. www.pw.org

Residencies

You can find residencies across the country and around the globe. Many will be listed on websites that list grants. The following resources list residencies exclusively.

Alliance of Artist Communities. This organization publishes a directory and offers a fee-based residency search engine on its website that costs $25 per year. www.artistcommunities.org/about-residencies

Artists' Communities: A Directory of Residencies That Offer Time and Space for Creativity, 3rd ed. New York: Allworth Press, 2005. Published by the Alliance of Artist Communities, this book lists more than three hundred residency programs worldwide "for creative individuals of all kinds" with detailed profiles and photographs of ninety-five U.S. artist communities. Six artists describe their residency experiences in detail.

Beltway Poetry Quarterly Resource Bank. Free listing of national and international residencies (at national parks, colleges, or museums), artist colonies, and retreat programs. www.washingtonart.com/beltway/resid1.html

Res Artis. A free listing of international residency opportunities. www.resartis.org

Trans Artists. A free listing of international artist-in-residence programs. www.transartists.org

Books and Websites About Grant Writing

Colvin, Gregory L. *Fiscal Sponsorship: 6 Ways to Do It Right.* San Francisco, Calif.: Study Center Press, 2005. This book is for overachievers who crave the details of various types of fiscal sponsorship arrangements. (Note: The first edition [1993] is identical to the second edition [2005] except for an extended postscript.)

Grant Proposal Writing Tips. Washington, D.C.: Corporation for Public Broadcasting. A concise online guide to writing grant proposals. www.cpb.org/grants/grantwriting.html

Geever, Jane C. *The Foundation Center's Guide to Proposal Writing.* New York: Foundation Center, 2007. An entire book devoted to the details of proposal writing, with many examples and a sample proposal. It's not geared specifically for individual artists but is helpful nonetheless.

Karsh, Ellen, and Arlene Sue Fox. *The Only Grant-Writing Book You'll Ever Need: Top Grant Writers and Grant Givers Share Their Secrets.* New York: Basic Books, 2009. Although geared to organizations, key strategies and examples are pertinent to individual grant seekers.

Thompson, Waddy. *The Complete Idiot's Guide to Grant Writing.* New York: Alpha Books, 2011. Although only one chapter covers grant writing for individuals, this book is brimming with no-nonsense information on all aspects of the process. A lively and thorough guide.

Warshawski, Morrie. *Shaking the Money Tree: The Art of Getting Grants and Donations for Film and Video Projects* (3rd ed.). Studio City, CA: Michael Wiese Productions, 2010. A bible for fundraising for film and video, Warshawski's organized, wise, and inspiring book is a must-have. More resources are available on the author's website. www.warshawski.com/bibliography.html

Warshawski, Morrie. *The Fundraising Houseparty: How to Party with a Purpose and Raise Money for Your Cause* (2nd ed.). Napa, CA: Morrie Warshawski, 2007. This slim step-by-step guide to the fundraising house party contains examples of invitations, detailed instructions on party planning, and follow-up advice to ensure success.

Additional Resources to Support Your Career

Writing

Goldberg, Natalie. *Writing Down the Bones: Freeing the Writer Within*. Boston, Mass.: Shambhala, 1986. This book is your guide to freewriting.

Marks, Andrea. *Writing for Visual Thinkers*. New York: AIGA Design Press, 2008. A beautifully designed e-book on writing for artists and designers. Includes many techniques, assignments, and links to useful and inspiring resources. (www.aiga.org/content.cfm/writing-for-visual-thinkers).

O'Conner, Patricia. *Woe Is I: The Grammarphobe's Guide to Better English in Plain English*. New York: Riverhead Books, 2009. A witty reference guide on usage, grammar, and punctuation, with clear examples.

Strunk, William, Jr., and E. B. White. *The Elements of Style*. New York: Longman, 1999. Treat yourself to the illustrated version of this classic, concise writing guide—the only one you really need.

Zinsser, William. *On Writing Well, 30th Anniversary Edition: The Classic Guide to Writing Nonfiction*. New York: HarperCollins, 2006. Zinsser's warm and wise handbook grew out of the course he taught at Yale. For writers at all levels.

Creativity and Perseverance

Bayles, David, and Ted Orland. *Art and Fear: Observations on the Perils (and Rewards) of Artmaking*. Eugene, OR: Image Continuum Press, 2001. Run, don't walk, to your library or bookstore and find this book, an encouraging, honest survival guide about finding and walking your own path in life and art.

Cameron, Julia. *Finding Water: The Art of Perseverance*. New York: Jeremy P. Tarcher/Penguin, 2009. Twelve weeks of lessons that inspire tenacity.

Henri, Robert. *The Art Spirit*. New York: Basic Books, 2007. My painting teacher Phil Sylvester reads randomly from this book during studio classes. Originally written in 1923, *The Art Spirit* contains jewels on every page about the power and meaning of life and art. A must-read for all artists.

Pressfield, Steven. *The War of Art: Break Through the Blocks and Win Your Inner Creative Battles*. New York: Warner Books, 2003. This book is a kick in the ass to your inner critic and a karate-chop to any internal resistance.

Money and Financial Planning

Crawford, Tad. *The Secret Life of Money: How Money Can Be Food for the Soul*. New York: Allworth Press, 1994. An investigation into money's history, meaning, and symbolism from many cultures. You'll never look at money the same way.

Stanny, Barbara. *Overcoming Underearning: A Five-Step Plan to a Richer Life*. New York: HarperCollins, 2005. You'll never undercharge for your services again after reading this book. Stanny's five-step plan sounds simple but reaches to the core of how to value yourself and respect your money. An eye-opener.

Tyson, Eric. *Personal Finance for Dummies*. Hoboken, NJ: Wiley, 2006. An entertaining and useful guide covering every aspect of personal finance, from budgets to taxes, saving, investing, insurance, and how to financially survive life's biggest changes. All the details you'll ever need about personal finance.

Psychological Support

Aron, Elaine N. *The Highly Sensitive Person: How to Thrive When the World Overwhelms You*. New York: Three Rivers Press, 1998. Just because you're sensitive doesn't mean you have a disorder. In fact, 15 to 20 percent of the population is highly sensitive and many of them are artists. This book teaches you how to thrive and succeed both because of and despite your sensitive tendencies. A life-changing read.

Miller, Alice. *The Drama of the Gifted Child: The Search for the True Self.* New York: Basic Books, 2008. A beautiful and profound book about discovering your own needs, acknowledging a painful childhood, and reclaiming your own life.

Chödrön, Pema. *When Things Fall Apart: Heart Advice for Difficult Times.* Boston: Shambhala, 2002. Written by an American Buddhist nun, this book teaches how to withstand painful emotions and cultivate compassion and courage, no matter the chaos of the present moment.

Viorst, Judith. *Necessary Losses: The Loves, Illusions, Dependencies, and Impossible Expectations That All of Us Have to Give Up in Order to Grow.* New York: Fireside, 1998. Cuts to the core of how to let go so you can grow up. Required reading for anyone aspiring to be an adult.

Career Guidance

Lloyd, Carol. *Creating a Life Worth Living.* New York: Harper Paperbacks, 1997. Filled with interviews with successful artists and fun, creative exercises for finding, creating, and pursuing work you love. It's out of print so you'll have to track down a used copy.

ARTISTS

Artspire. *The Profitable Artist: A Handbook for All Artists in the Performing, Literary, and Visual Arts.* New York: Allworth Press and the New York Foundation for the Arts, 2011. This book covers all topics relevant to the artist on her way to success including: strategic planning, finances, legal issues, marketing, and fundraising.

Battenfield, Jackie. *The Artist's Guide: How to Make a Living Doing What You Love.* Cambridge, MA: Da Capo Press, 2009. Filled with photographs of many artist works, this inspiring book is a practical guide on how to succeed as an artist. Includes sections on setting goals, networking, researching, building community, managing finances and daily operations, applying for grants, and much more.

Bhandari, Heather Darcy, and Jonathan Melber. *ART/WORK: Everything You Need to Know (and Do) As You Pursue Your Art Career.* New York: Free

Press, 2009. Written with clarity and wit, this book offers practical advice on all aspects of the business of art. Includes how to prepare submissions, open a studio, build a website, handle galleries, write grants. Brimming with inspiring quotes from artists and funders.

Borden, Phil. *Business of Art: An Artist's Guide to Profitable Self-Employment.* Los Angeles: Center for Cultural Innovation, 2012. This book offers advice to artist entrepreneurs, from goal setting to self-promotion, financial planning, legal issues, and business plans.

Michels, Caroll. *How to Survive and Prosper As an Artist: Selling Yourself without Selling Your Soul* (6th ed.). New York: Henry Holt and Co., 2009. This comprehensive book covers all aspects of a successful career in the arts, including one chapter on grants. The gigantic resource appendix alone is worth the cover price. Michels maintains the Artist Help Network (www.artisthelpnetwork.com), a wealth of information on topics from career development to safety hazards and health insurance.

Smith, Constance. *Art Marketing 101: A Handbook for the Fine Artist.* Nevada City, CA: ArtNetwork Press, 2007. Loaded with forms, checklists, and advice on topics from the psychology of success to business basics, shipping, résumés, galleries, and marketing.

Stanfield, Alyson B. *I'd Rather Be in the Studio: The Artist's No-Excuse Guide to Self-Promotion.* Golden, CO: Pentas Press, 2008. A lively, kick-in-the-pants marketing guide for artists. Stanfield offers a free weekly newsletter with marketing tips and sells other artist services through her website (www.artbizcoach.com/).

Vitali, Julius. *The Fine Artist's Guide to Marketing and Self-Promotion.* New York: Allworth Press, 2003. With an entire chapter on grants and another on corporate sponsorship, this book delivers more than the title promises. Many examples of working artists included.

FILMMAKERS & MUSICIANS

Baker, Kelley. *The Angry Filmmaker Survival Guide Part I: Making the Extreme No-Budget Film.* Portland, OR: Angry Filmmaker, 2009. Even if you're not a filmmaker, this book is a motivating and informative read. Baker's anger is the healthy and productive kind and his stories remind you how much of your career success is in your own hands. Baker's extreme no-

budget advice is wise and he's such an engaging storyteller that the book is hard to put down.

Simmons, Jade. *Emerge Already! The Ultimate Guide to Career Building for Emerging Artists.* Houston, TX: Jade Media, 2011. Although this book is geared for the performing musician, Simmons writes with grace and humor about how to be the boss of your own art. This book is a must read for performers and inspiring and empowering for every artist entrepreneur.

WRITERS

Eiben, Therese, and Mary Gannon, eds. *The Practical Writer: From Inspiration to Publication.* New York: Penguin Books, 2004. This anthology of advice for the emerging writer, presented by *Poets & Writers* magazine, covers the gamut of topics from the writing studio through publication.

Gore, Ariel. *How to Become a Famous Writer Before You're Dead: Your Words in Print and Your Name in Lights.* New York: Three Rivers Press, 2007. This guidebook brims with interviews with successful writers and Gore's hip guidance on craft, promotion, and publishing. Wise and inspiring, and you won't be able to put it down.

Katz, Christina. *Get Known Before the Book Deal: Use Your Personal Strengths to Grow an Author Platform.* Cincinnati: Writer's Digest Books, 2008. No time for moping with this motivating book on how to influence your future as an author. An enthusiastic read on how to build an audience and grow a career.

Other Resources

Guidestar. Free access to a database of nonprofits' 990 forms, which nonprofits use to report their income and expenses to the IRS. These forms are a great resource for researching the projects an organization has funded in the past. Most organizational websites include a list of current board members. The Form 990 lists an organization's former board members. The information on a Form 990 is usually one or two years behind. www.guidestar.org

GYST: An Artist Run Company for Artists. Karen Atkinson's company offers many reasonably priced artist services, including GYST software, which tracks artwork, prices, and sales and provides invoices, a mailing list database, and an artwork checklist for exhibitions. Also available is a program that guides users through the process of writing proposals with detailed instructions and support. www.gyst-ink.com/products

Sher, Barbara, and Annie Gottlieb. *Teamworks!* New York: Warner Books, 1990. Great, step-by-step advice on building one-on-one partnerships and "success teams." It's out of print so you'll have to track down a used copy.

about the author

Gigi Rosenberg is a writer, speaker, and workshop leader. This book grew out of the professional development workshops she launched in Portland, Oregon, and teaches in New York, Chicago, and throughout the Pacific Northwest at colleges, conferences, and arts organizations. Her writing has been published by Seal Press, *The Oregonian*, *Parenting and Writer's Digest*, performed at Seattle's On the Boards; and broadcast on Oregon Public Radio. For the latest, visit www.gigirosenberg.com.